SPECTACULAR DISPLAY

The Art of Nkanu Initiation Rituals

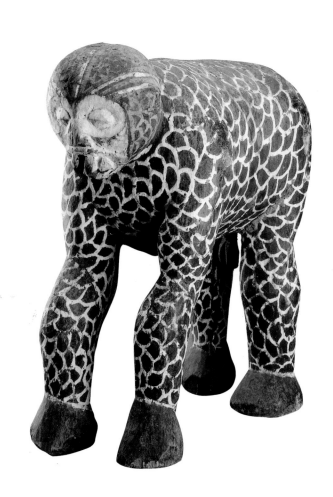

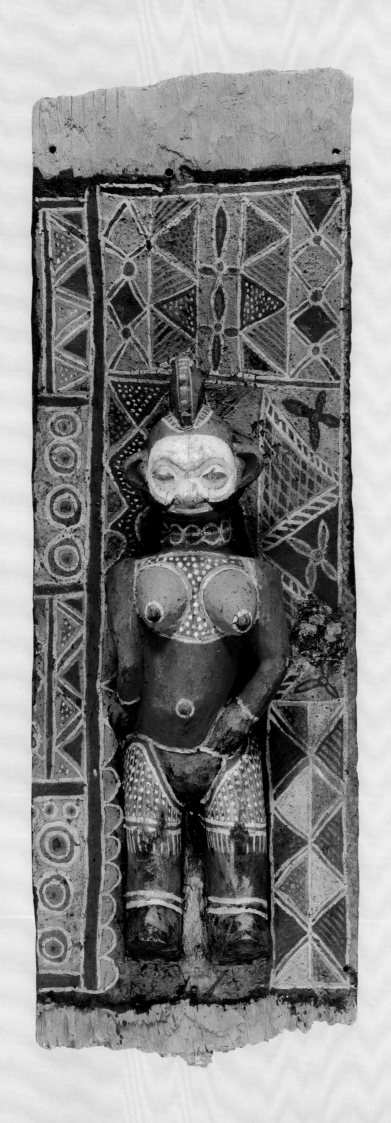

SPECTACULAR DISPLAY

The Art of Nkanu Initiation Rituals

Annemieke Van Damme

with an introduction by

David A. Binkley

Smithsonian
National Museum of African Art

in association with
Philip Wilson Publishers

Published in conjunction with the exhibition, *Spectacular Display: The Art of Nkanu Initiation Rituals*, organized by the National Museum of African Art, December 16, 2001–March 3, 2002.

Edited by Migs Grove
Translated by Gert Morreel
Designed by Andrew Shoolbred
Printed in Italy by EBS, Verona

The text is printed on 150 gsm matt coated cartridge. The paper used in the publication meets the minimum requirements of the American National Standard for Information Sciences—Permanence of Paper for Printed Library Materials ANSI Z39.48-1984

First published by Philip Wilson Publishers, 7 Deane House, 27 Greenwood Place, London NW5 1LB

Distributed in the USA and Canada by Antique Collectors' Club, 91 Market Street Industrial Park, Wappingers' Falls, New York 12590

ISBN: 0 85667 554 7

Cover (detail)
Cat. no. 7
Initiation wall panels
Nkanu peoples, Democratic Republic of the Congo
National Museum of African Art, Smithsonian Institution, museum purchase, 992-1

Frontispiece
Cat. no. 3
Wall panel
Nkanu peoples, Democratic Republic of the Congo
Collection of the Jesuit Fathers, Heverlee, on permanent loan to the Africa Museum, Tervuren, 1340

Catalogue opener
Cat. no. 10
Wall panel
Nkanu peoples, Democratic Republic of the Congo
Collection of the Jesuit Fathers, Heverlee, on permanent loan to the Africa Museum, Tervuren, 48.8.1

Contents

Photographic credits

Acknowledgements

The art associated with Nkanu initiation rituals is surely a major sculptural tradition in central Africa in part because of its spectacular forms and, yet, surprisingly little of it has ever been displayed. This is due to the paucity of objects in public and private collections and the lack, until recently, of field research to interpret the forms and content of this complex artistic tradition.

The impetus for mounting this exhibition was the National Museum of African Art's acquisition of five Nkanu polychromed wall panels in 1998. Shortly after their acquisition, the museum's deputy director and chief curator, David Binkley, contacted Dr. Annemieke Van Damme about contributing to a catalogue on the Nkanu arts associated with *nkanda* (coming-of-age) rituals. Van Damme's commitment to the project led to discussions with the Royal Museum for Central Africa (Africa Museum, Tervuren), the major repository of Nkanu art. Tervuren's rich collection has been augmented by the permanent loan of the Nkanu collection of the Jesuit Fathers, Haverlee, Belgium.

The exhibition has come to fruition because of the Royal Museum's enthusiastic response to our request. I would like to thank the museum's staff for sharing these exceedingly rare and important works of *nkanda* art, especially: the director Guido Gryseels; Jos Gansemans, head of the Department of Cultural Anthropology; Gustaaf Verswijver, the acting head of the Ethnography Division; associate curators Boris Wastiau, Anne-Marie Bouttiaux, and Viviane Baeke; and conservator Françoise Van Hauwaert.

I am also grateful to Dr. Gundolf Krüger from the Institut für Ethnologie der Universität Göttingen, Abteilung Völkerkundliche Sammlung, for lending a rare Kisokolo mask with costume and two *nkanda* head posts; Corice and Armand P. Arman for lending a Kakungu mask; Donald and Adele Hall for lending an important leopard figure; and Marc Leo Felix for lending a standing female figure. Photographs of other Nkanu objects that appear in the catalogue include a Kakungu head post from the Iris & B. Gerald Cantor Center for Visual Arts, Stanford University, wall panels from the Sociedade de Geografia de Lisboa, and a wall panel from the Broeders van Lourdes, Oostakker, Belgium.

I am indebted to the entire staff of the National Museum of African Art and extend special thanks to chief conservator Steve Mellor and assistant conservator Dana Moffett, who treated the objects before they were photographed by Franko Khoury. Mount maker, Keith Conway, imaginatively created intricate object mounts, including those for three *nkanda* wall panel groupings. I would also like to acknowledge: the design department headed by Alan Knezevich and designers Lisa Vann and David Hsu for their detailed work on maps included in the catalogue and exhibition; the registration department, headed by Julie Haifley, for organizing the packing and shipping of the objects from Belgium, Germany and America; and assistant director Patricia Fiske, who worked out the contractual aspects of the exhibition and catalogue. Special thanks go to the author of the catalogue, Annemieke Van Damme; the translator, Gert Morrell; and David Binkley and the museum's editor Migs Grove who shaped the exhibition catalogue text. In addition, curator Christine Mullen Kreamer read initial drafts of the catalogue and assisted Binkley in the development of the exhibition materials. They were aided in this enterprise by intern Jos Thorne.

Rosyln Adele Walker
Director
National Museum of African Art

7

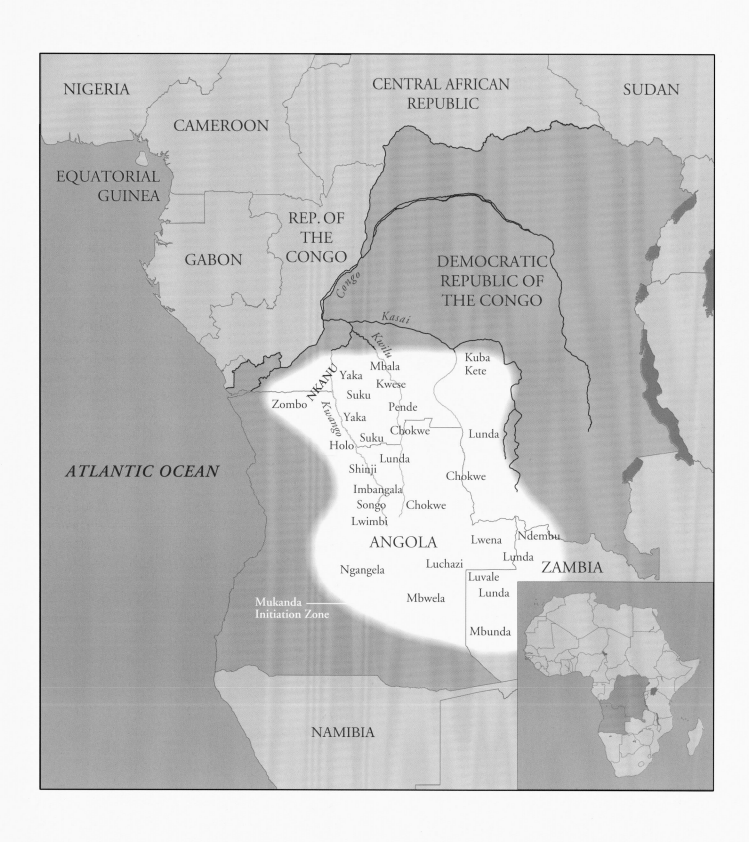

NIGERIA

CAMEROON

CENTRAL AFRICAN
REPUBLIC

SUDAN

EQUATORIAL
GUINEA

GABON

REP. OF
THE
CONGO

Congo

DEMOCRATIC
REPUBLIC OF
THE CONGO

Kasai

Kwilu

Kuba
Kete

NKANU

Yaka

Mbala

Kwese

Suku

Zombo

Kwango

Yaka

Pende

Chokwe

Lunda

Suku

ATLANTIC OCEAN

Holo

Lunda

Shinji

Chokwe

Imbangala

Songo

Chokwe

Lwimbi

ANGOLA

Lwena

Ndembu

Lunda

ZAMBIA

Ngangela

Luchazi

Luvale

Lunda

Mukanda
Initiation Zone

Mbwela

Mbunda

NAMIBIA

Coming of age in central Africa

David A. Binkley

Rites of passage in one form or another are practiced in every society in the world. The most common forms are connected with the marked passage of individuals and groups from one social or cultural status to another. In central Africa, the rites take place at key moments in an individual's life—such as birth, coming of age, and death. These momentous occasions usually mark dramatic and irrevocable changes in the social relationships of the persons involved. Rites of passage clarify these changes and celebrate them before the entire community.

In many African cultures a rite of passage at puberty or at sometime before physical maturity is an essential part of every person's education. To be physically an adult and not initiated is to be socially a child, virtually lost in a world without the prerequisite knowledge that regulates adult behavior and without establishing the social parameters of adult maleness or femaleness that society demands.[1] In most cases, boys and young men are initiated in coming-of-age rites that are separate from girls and young women. Often, the attainment of higher status, such as holding a title in a community organization or participating in any of a number of adult activities, is not permitted if one does not complete the rite. That is why in many cultures initiation is mandatory.

The declared purpose of initiation rites is one of transformation: to make children into adults. For men, the rites are believed to ensure the creation of responsible adults as defined by the norms of a society. There are other declared initiation goals. One is respect for the authority of elders, especially community leadership. Rites of passage reaffirm to the next generation the hierarchy of leadership in the community. At the summit are those individuals who oversee the progress of the rite and direct the activities of those who are just beginning the process as neophytes.

The newly initiated begin on the bottom social rung and may move up in the hierarchy over the course of their lifetimes. While not all initiation rites confer automatic membership into a secret society or organization, this is often the result of such activities. Peer group allegiance is also fostered during rites of passage through the shared experience of the rite and the oath that initiates take at the conclusion of the rite. The acquisition of some ritual knowledge through participation in the rite often allows one to take part throughout his lifetime in other initiation-related activities, such as funeral rituals that require the direct experience of initiation.

Secrecy is a constituent part of virtually all initiation proceedings. Secrets are transmitted during the rite and at the close of the rite an oath is taken to maintain the secret knowledge between members who have been initiated. In Southern Kuba culture in central Africa initiated men will often say to the uninitiated, "If you want to learn the secrets of initiation, go and see for yourself"; that is, the only access to the secret knowledge imparted during the initiation is through direct participation in the rite.

Nkanu initiation rituals are similar to other forms practiced from eastern Angola to southwestern Democratic Republic of the Congo and western Zambia (see map on p. 15). The rituals are usually called *mukanda* or *nkanda* and are accompanied by an artistic complex that includes a variety of fiber and wooden masquerade figures, sculpture, elaborate costuming, and special dances, and musical accompaniment.[2] *Mukanda* is not practiced uniformly across this region. Variations in the form, aesthetic content, and frequency are found among peoples who practice *mukanda,* and these variations relate to historical circumstances and cultural preferences.

The organization of *mukanda* illustrates the structure of rites of passage described by the French anthropologist and folklorist Arnold van Gennep.[3] *Mukanda* is organized into three distinct phases: separation, transition, and reintegration. A dominant theme of the rite is the symbolic death and rebirth of the individual, who enters *mukanda* as a child and re-enters society at the conclusion of the rite as an adult. For boys and young men, the separation is also a major social reorientation from the world of women to that of men. This change is complete and irrevocable as each society defines the social categories of adult men and women.

Separation

At the onset of *mukanda,* the group of boys or young men who participate leave their homes and families and are sequestered in a specially constructed enclosure that is usually situated outside the community in the forest. The separation from home

Opposite: Only some of the peoples who practice *mukanda* in the region are indicated on the map. The geographic limits of *mukanda,* historically and as currently practiced, are uncertain because insufficient data exists.

and family may range from several days to several months or longer. Even though children who participate in *mukanda* may not be biologically and socially mature enough to actually accept adult responsibilities, such as marriage and the rearing of children, until sometime in the future, *mukanda* does bring them into the sphere of adult male control and helps to guide them as they mature physically into manhood.

Locating the enclosure away from the community is an important element in the dramatic content of the rite. Spatial boundaries solidify and reinforce opposition between the participants and outsiders—the uninitiated, especially those of the opposite sex. Much of the symbolic content of *mukanda* is centered on the juxtaposition of males and females and their social, cultural, and spatial domains. Upon entering the enclosure, the initiates are identified with the wild, uncivilized, and dangerous spaces outside the community—the world of men. The community on the other end is identified with female spheres of activity—civilized and domesticated life. The world of men outside the community is also identified as the realm of nature spirits or ancestral spirits that may be conceptualized as the principal spirit forces which sanction initiation rituals. Their blessings are a necessity if *mukanda* is to begin and be completed successfully. Other juxtapositions, including themes of life, death, and rebirth, may also be present. The initiation enclosure may be referred to as a cemetery and the initiates as the dead. The initiates may also be referred to as insects, wild animals, or other creatures of the forest realm. These juxtapositions also relate directly to other themes that find resonance in many central African belief systems.

Transition

For the individuals, the transition period is a time of isolation from what they have experienced in their past lives. During this intermediate stage, special rules of conduct are enforced that emphatically separate the initiates from the non-initiated—especially women. It is a period of profound change in which the individuals are brought into close contact with others of approximately the same age. Isolated from their former homes and families, the initiates assume a new identity. Both physical and psychological changes occur that heighten the initiate's experience of the rite. While circumcision may not be a critical element of the rite, other forms of bodily change or alteration may take place. The initiates' heads may be shaved into special patterns and their bodies may be covered with brightly colored pigment. Other temporary forms of body decoration may be worn at significant points during the rite. Special clothing confirming the initiates' liminal status may be worn, or, at certain key moments, nudity may be required.

The transition phase is also the period when creatures from the supernatural world are brought into being through the skilled hands of mask makers and sculptors. As a time of heightened symbolism, *mukanda* invokes a variety of masquerade figures that may serve as guardians or instructors, or as role models of proper behavior. They may also serve as negative role models displaying everything that a properly initiated person should not do, thus reinforcing the value of participation in the rite for the initiates. Masquerade figures are often conceptualized as a locus of power and authority because they are associated with ancestral or spirit forces. These spirit forces are thought to sanction and empower the elders conducting the *mukanda* to safeguard the neophytes as they brave circumcision and proceed along a path of irrevocable change away from the sphere of women to that of men. Masquerade figures also serve an important entertainment function. They help to lessen the initiates' stress during the extended period of time they are sequestered in the *mukanda* enclosure. Masquerade figures may also occasionally bring news of the initiates to their mothers and other family members who reside in the community.

During the transition period the initiates are taught practical life skills such as hunting, fishing, or the making of traps. Training in the proper behavior toward other initiates, toward one's superiors, and toward women are also aspects of this informal training. Other forms of instruction may be both practical and esoteric. This includes the exposition of artistic skills, such as the making of sculpture, masks, special costumes, and other forms of initiation regalia. Initiation songs and dances are also practiced in the *mukanda* enclosure in preparation for the concluding celebration. Among central African peoples like the Pende, Chokwe, Yaka, Suku, and Kuba living in the southern savanna of southwestern Democratic Republic of the Congo, a portion of the *mukanda* instruction is devoted to the performing arts. The initiates learn special songs and dances and make distinctive musical instruments that are only performed within the context of the men's initiation society. Instruction may also include mastering techniques necessary to fabricate and dance masquerade figures. Among the Southern Kuba and Northern Kete, for example, initiates may not only observe initiation masquerade figures being made, but may actually participate in their fabrication, making costume accessories such as fringed collars or skirts. They may also be asked to collect materials that are utilized in the construction of masked costumes and other paraphernalia.[4]

While certain skills, such as the fabrication or carving of masquerade figures, may not actually be taught to the initiates, they do see these activities and learn a great deal about the number of different individuals and skills that are prerequisite to the successful presentation of a masquerade figure. Building a degree of practical, aesthetic, and esoteric competence in the group of initiates is critical if all aspects of the rite are to be passed on to the next generation. There are also more esoteric forms of instruction, including secret words, phrases, songs, proverbs or riddles, that extol the power of the initiation rite and the status which comes to those who have completed *mukanda.*

The ascribed purpose of *mukanda* and its accompanying artistic expressions is calculated to transform the novices, through the acquisition of both practical and esoteric knowledge, into fully participating adult members of the community. Gerhard Kubik states that indigenous interpretations "always emphasize the educational and socializing function and purpose of *mukanda*" (1978). Both African and Western writers have characterized *mukanda* as a form of traditional schooling. In discussing *mukanda* initiation in Zambia, W.R. Mwondela notes that the initiates "were instructed in all aspects of adult life, lecturers coming from all parts of the locality . . . Among other subjects, instruction was given in dancing, singing, folklore, handicrafts and sexual life" (1972: 9). Like Mwondela, Victor Turner describes the goal of *mukanda* as that of returning the initiates to society "as purified and socially mature" individuals (1967: 276). And Biebuyck, following information published by Mudiji-Malamba (1979), describes *mukanda* among the Central Pende as a place where "candidates are intensely instructed in male techniques, history, social milieu, and esoteric language during this period" (1985: 223).

The initiation camp should not, however, be thought of as a school with formalized instruction. Gilbert Lewis, in discussing initiation rituals among peoples living in the West Sepik Province of Papua New Guinea notes, "there is little of the school about them, no set periods of instruction. Learning is a matter more of practice and experience, of chance remarks which explain or interpret, individual views, and less a body of ideas and doctrines consistently and purposefully taught" (1980: 98). My own experience of initiation rites among the Southern Kuba of the Democratic Republic of the Congo suggests a similar approach to instruction. Those initiates who actively participate in the initiation or who are astute observers clearly benefit the most from the experience. Southern Kuba elders believe that it is these individuals who will ultimately be more successful, that is, obtain an important and influential titled position during their lifetime.

Reintegration

Like the transition period described above, the subsequent reintroduction of the initiates into society as adults at the end of *mukanda* is a period of intense artistic and symbolic expression. While masks may appear occasionally throughout the initiation period, their appearance is pervasive at the concluding celebratory dance. The initiates' appearance at this dance before the entire community marks the public recognition of the initiate's new status. Presented much like a recital, the initiates wear their special initiation costumes and perform the special dances they practiced in the forest camp. It is also a celebration for family and friends—both men and women—who have exerted extra effort in order to make certain that the rite was completed successfully. It is a special time of recognition for those guardians, instructors, and artisans who instructed the initiates in the enclosure.

The sexual symbolism that is rife during the transition phase of *mukanda* is often further heightened at the reintegration festivities. The celebration dramatizes the symbolic rebirth of the initiates as adults. It emphasizes their social and sexual maturity as individuals who are biologically and psychologically mature and have the capacity to conceive and direct the next generation. The entire process may be underwritten by the ancestral spirits that are invoked to safeguard the well being of the initiates and the successful outcome of *mukanda*.

At the conclusion of *mukanda*, the initiates take an oath declaring they will not disclose the secret knowledge acquired in the initiation camp. The oath is a serious affair that is sustained by both peer group pressure and the hierarchy of community leadership. The experience of *mukanda* is different for every individual, but many older men have said it was the most profound experience of their lives.

The arts of *mukanda* today

It is difficult to assess the overall importance of *mukanda* to many central African peoples today. The institution of *mukanda* was, as have other African religious and cultural institutions, assailed increasingly in the nineteenth and twentieth centuries. Certainly the long history of colonialism and its oppression of traditional cultural and religious practices have affected rites of passage in central Africa. Western education, health, and religious practices have also impacted the complexity and frequency of *mukanda* and even its viability in the face of unprecedented political, economic, and social change. In recent decades, civil war has caused tremendous social and political upheavals in much of the region as well.

Jürgen Osterhammel notes that "colonial regimes and missionaries acted to undermine native cults and religious convictions with differing degrees of zeal . . . [and African peoples] . . . proved resistant to quite varied degrees. . . . Never did imported 'modernity' and local 'tradition' merely clash or co-exist. Instead new blends evolved."[5] Precisely how these influences resonate in contemporary *mukanda* practice is difficult to ascertain because in-depth historical descriptions of *mukanda* practice are often lacking for most of the cultures in the central African region. Moreover, the evidence of change in the twentieth century is often incomplete and anecdotal.

For Nkanu peoples residing in the Democratic Republic of the Congo, *mukanda* is practiced sporadically at the present time, while for Nkanu residing in Angola, the rites appear to continue unabated. In response, some Congolese Nkanu parents send their boys to Angola to participate in *mukanda*. During the 1960s, Daniel Crowley notes that Chokwe parents residing in urban centers in Zambia would send their sons back to their ancestral communities for *mukanda*. He adds that after

the initial repression of *mukanda,* both Catholic and Protestant missionaries began to see the value of the institution and supported it (1982: 210). In other regions, the institution has not fared as well. *Mukanda* is no longer practiced by many Central Pende peoples residing in the Democratic Republic of the Congo.[6] Research among the Southern Kuba and Northern Kete suggests that both colonial administrative and missionary repression of initiation practices were at times severe and, yet, the rites continued unabated throughout the region. In the Northern Kuba region coming-of-age rites are actually expanding into communities that have never practiced the rites before. This is, in part, a response to titled elders who explain that the rites are needed to counteract antisocial behavior and the decline in respect accorded community leaders by the youth in their communities.

The goal of *mukanda* and its spectacular display of masks, wall panels, and sculpture is to educate the youth who take part in the rite and to encourage their acceptance of the authority of community leaders. Different communities have responded in different ways to the dramatic political, economic, and cultural forces of change that continue to assail their societies' values. Many of them continue to find relevance in the institution of *mukanda* to satisfy the goal of creating responsible young adults.

Notes

1 The distinctions between childhood and adulthood are socially defined by a culture and have little to do with an individual's physical or psychological development. For this reason, ages may vary dramatically among members of an initiation group.

2 This overview focuses on male rites of passage. In most cases, separate rites of passage are held for girls or young women, while in some societies girls do not undergo specialized rites at all. See further reading list for several studies of initiation rites for girls and young women.

3 Van Gennep (1873–1957) first employed the term "rites of passage" (1909; translation, Chicago: University of Chicago Press,1960).

4 Daniel Crowley also describes how the initiates "learn how to make wooden and bark cloth masks and the knitted fiber costumes that complete paraphernalia of the masked personages who run the *mukanda* lodge." Crowley, Daniel. 1971. "An African Aesthetic." In *Art and Aesthetics in Primitive Societies,* ed. Carol F. Jopling (New York: E.P. Dutton & Co., Inc.), p. 318.

5 Jürgen Osterhammel. *Colonialism, A Theoretical Overview,* trans. Shelley L. Frisch (Princeton: Markus Wiener Publishers, 1999), p. 97.

6 See Z.S. Strother. *Inventing Masks: Agency and History in the Art of the Central Pende* (Chicago: University of Chicago Press, 1998).

Further reading

Rites of passage

Bellman, Beryl L. 1984. *The Language of Secrecy, Symbols and Metaphors in Poro Ritual.* Rutgers, N.J.: Rutgers University Press.

Bettelheim, Bruno. 1954. *Symbolic Wounds.* Glencoe, Ill.: Free Press.

Bloch, Maurice & Parry, Jonathan., eds. 1982. Introduction. In *Death and the Regeneration of Life.* New York: Cambridge University Press.

Eliade, Mircea. [1958] c. 1994. *Rites and Symbols of Initiation: The Mysteries of Birth and Rebirth.* Trans. Willard R. Trask. Dallas and Woodstock, Conn.: Spring Publications.

Gennep, A. van. [1909] 1960. *The Rites of Passage.* Trans. Monika B.
Vizedom and Gabrielle L. Caffee. Chicago: The University of Chicago Press.

La Fontaine, J.S. 1985. *Initiation—Ritual Drama and Secret Knowledge Across the World.* Harmondsworth, England: Penguin Books Ltd.

Lewis, Gilbert. 1980. *Day of Shining Red, An Essay on Understanding Ritual.* New York: Cambridge University Press.

Central African initiation rites

Bastin, Marie Louise. 1986. "Ukele. Initiation des adolescents chez les Tshokwe (Angola)." *Arts d'Afrique Noire* 57: 15–30.

Biebuyck, Daniel. 1985. *The Arts of Zaire.* Vol. 1, *Southwestern Zaire.* Berkeley and Los Angeles: University of California Press.

Binkley, David A. 1987a. "Avatar of Power: Southern Kuba Masquerade Figures in a Funerary Context." *Africa* 57 (1): 75–97.

_____. 1987b. "A View from the Forest: The Power of Southern Kuba Initiation Masks." Ph.D. diss., Indiana University, Bloomington.

_____. 1990. "Masks, Space and Gender in Southern Kuba Initiation Ritual." *Iowa Studies in African Art* 3.

_____. 1996. "Bounce the Baby: Masks, Fertility and the Authority of Esoteric Knowledge in Northern Kete Initiation Rituals." Elvehjem Museum of Art Bulletin/Annual Report 1993–95 (University of Wisconsin-Madison): 45–56.

Bourgeois, Arthur P. 1980. "Nkanda-Related Sculpture of the Yaka and Suku of Southwestern Zaire." Ph.D. diss., Indiana University, Bloomington.

_____. 1982 "Yaka Masks and Sexual Imagery." *African Arts* 25 (2): 47–50, 87.

_____. 1984. *Art of the Yaka and Suku.* Meudon, France: Alain et Françoise Chaffin.

_____. 1985. *The Yaka and Suku.* Iconography of Religions, 7, D1. Leiden: Brill.

Cameron, Elizabeth. 1995. "Negotiating Gender: Initiation Arts of Mwadi and Mukanda among the Lunda and Luvale, Kabompo District, North-Western Province, Zambia." Ph.D. diss., University of California, Los Angeles.

Crowley, Daniel. 1972. "Chokwe: Political Art in a Plebian Society." In *African Art and Leadership.* Ed. Douglas Fraser and Herbert M. Cole. Madison: University of Wisconsin Press, pp. 21–39.

_____. 1982. "Mukanda: Religion, Art and Ethnicity in West Central Africa." In *African Religious Groups and Beliefs: Papers in Honor of William R. Bascom.* Ed Simon Ottenberg. Meerut, India: Archana Publications for the Folklore Institute, pp. 206–21.

Darish, Patricia J. 1990. "Dressing for Success: Ritual Occasions for Ceremonial Raffia Dress among the Kuba of South-central Zaire." *Iowa Studies in African Art* 3: 179–91.

Devisch, Renaat. 1972. "Signification socio-culturelle des masques chez les Yaka." *Boletim da Instituto de Investigacao Científica de Angola* 9 (2):152–76

Felix, Marc Leo and Manuel Jordán. 1996. *Makishi Lya Zambia: Mask Characters of the Upper Zambezi Peoples.* Munich: Fred Jahn.

Gluckman, Max. 1954a. "Circumcision Rites of the Balovale Tribes." Rejoinder to C.M.N. White, *African Studies* 13: 87–92.

_____. 1954b. *Rituals of Rebellion in South-East Africa.* Manchester: Manchester University Press.

_____. 1982. "The Role of the Sexes in Wiko Circumcision Ceremonies." In *Social Structure.* Ed. Meyer Fortes. London: Oxford University Press.

_____. 1983. "Les Rites de Passage." In *Essays on the Ritual of Social Relations.* Ed. Max Gluckman. Manchester: Manchester University Press, 1–52.

_____. 1984. "Rituals of Rebellion in South-East Africa." In *Order and Rebellion in Tribal Africa.* London: Cohen and West, 110–36.

Hambley, W.D. 1935. "Tribal Initiation of Boys in Angola." *American Anthropologist* 37: 36–40.

Herreman, Frank, and Constantijn Petridis. 1993. *Face of the Spirits: Masks from the Zaire Basin.* Gent, Belgium: Snoeck-Ducaju & Zoon.

Herreman, Frank, ed. 2000. *In the Presence of Spirits: African Art from the National Museum of Ethnology, Lisbon.* New York: Museum for African Art.

Holdredge, C.P., and **Kimball Young.** 1927. "Circumcision Rites among the Bajok." *American Anthropologist* 29 (4): 661–69.

Jordán, Manuel. 1998. "Engaging the Ancestors: Makishi Masquerades and the Transmission of Knowledge among Chokwe and Related Peoples." In *Chokwe: Art and Initiation among Chokwe and Related Peoples*. Munich and New York: Prestel-Verlag.

Kubik, Gerhard. 1969. "Masks of the Mbwela." *Geographica, Revista de Sociedada de Geografica de Lisboa* 5 (20).

_____. 1974. "Music and Dance Education in *Mukanda* Schools of Mbwela and Nkangela Communities." In *Proceedings of the Lusaka Conference on Music Education,* June 15–22, 1971, Lusaka 1973. Reprinted in *Review of Ethnology* 4 (7–9).

_____. 1977. "Patterns of Body Movement in the Music of Boy's Initiation in Southeast Angola." In *The Anthropology of the Body*. Association of Social Anthropologists of the Commonwealth Monograph Series, ed. John Blacking, no.15. London and New York: Academic Press.

_____. 1978. "Boy's Circumcision School of the Yao—A Cinematographic Documentation at Chief Makanjila's Village in Malawi, 1967." *Review of Ethnology* 6 (1–7): 1–37.

_____. 1981. *Mukanda na makisi—Circumcision school and masks*. Audio recording (double LP with notes). Museum Collection MC11, Museum fur Völkerkunde, Berlin.

_____. 1993a. *Makisi—Nyau—Mapiko. Maskentraditionen im Bantu-sprachigen Afrika*. Munich: Trickster.

_____.1993b. "Die mukanda-Erfahrung. Zur Psychologie der Initiation der Jungen im Ost-Angola-Kulturraum." In *Kinder—Ethnologische Forschungen in funf Kontinenten*. Ed. Marie-Jose van de Loo and Margarete Reinhart. Munich.

Lengelo Guyigisa. 1980. *Mukanda, l'ecole traditionnelle pende*. Centre d'études ethnologiques, 2d ser., vol 59. Bandundu, Zaire.

Mudiji-Malamba Gilombe, Théodore. 1979a. "Les masques mbuya ou mukanda des Phende (Zaire): Contexte, production, styles et usages." Mémoire de de licence, Catholic University, Louvain-La-Neuve, Belgium.

_____. 1979b. "Le masque phende *giwoyo* du musée de l'Institut supérieur d'archéologie et d'histoire de l'art de l'Université Catholique de Louvain." *Revue des Archéologues et Historiens d'art de Louvain* 12:169–93.

Mwondela, W.R. 1972. *Mukanda and Makishi in North-Western Zambia*. Lusaka: National Educational Company of Zambia Limited.

Ngolo Kibango. 1976. *Minganji, Danseurs de Masques Pende*. Centre d'études ethnologiques, 2d ser., vol. 35/1. Bandundu, Zaire.

Plancquaert, M. 1930. *Les sociétiés secrètes chez les Bayaka*. Louvain, Belgium.

Richards, A. 1956. *Chisungu: A Girl's Initiation Ceremony among the Bemba of Northern Rhodesia*. London: Faber & Faber.

Torday, Emil, and T.A. Joyce. 1911. Notes ethnographiques sur les peoples communement appelés Bakuba, ainsi que sur les peuplades apparentées: les Bushongo. Brussels: Musée du Congo belge.

Tucker, J.T. 1949. "Initiation Ceremonies for Lwimbi Boys." *Africa* 19: 53–60.

Turner, Victor. 1967. *The Forest of Symbols: Aspects of Ndemu Ritual*. Ithaca: Cornell University Press.

Van Damme, Annemieke. 1998. "Beelden, maskers en initiatiepanelen bij de Nkanu en hun buren, de Mbeko en Lula. Socio-culturele context en stilistische analyse (Zone Kimvula, Kongo)." Ph.D. diss., Universiteit Gent, Belgium.

_____. 2000. "The Initiation Arts of the Zombo, Nkanu, Yaka, and Suku Peoples." In *In the Presence of Spirits, African Art from the National Museum of Ethnology, Lisbon*. Ed. Frank Herreman. New York: Museum for African Art.

Vansina, Jan. 1955. "Initiation Rituals of the Bushong." *Africa* 25: 138–53.

Vrydagh, P. Andre. 1977. "Makisi of Zambia." *African Arts* 10 (4): 12–19, 88.

White, C.M.N. 1953. "Notes on the Circumcision Rites of the Balovale Tribes." *African Studies* 12 (2): 41–56.

_____. 1961. *Elements in Luvale Beliefs and Rituals*. Rhodes Livingstone Institute Paper, 32. Manchester: Manchester University Press.

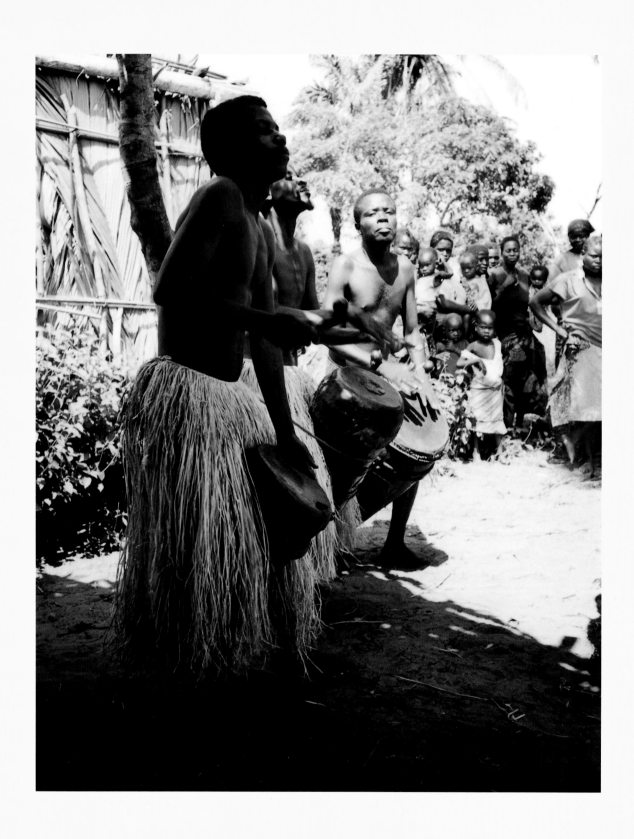

Situating nkanda

Annemieke Van Damme

The Nkanu inhabit the eastern part of the Lower Congo province of the Democratic Republic of the Congo and northern Angola (fig. 1). Approximately half of the Nkanu population lives in the Madimba and Kimvula zones of the Lower Congo province and the other half lives in Angola's Uige province.[1] Their neighbors include the Lula peoples and Dikidiki peoples to the north, the Mbeko peoples to the northwest, the Ntandu peoples to the west, the Yaka peoples to the east and southeast, the Zombo peoples to the southwest, and the Sosso peoples to the south.

The hilly terrain of the Kimvula zone includes the Plateau des Batékés, which reaches heights of up to 3000 feet (1000 m) at the border with Angola (fig. 2). The changes in the landscape's physical structure over time are manmade. Intentionally set bush fires and the prolonged use of the slash-and-burn method of farming radically altered the land, stimulating the formation of grassy plains and relegating the once plentiful forests to narrow strips along the river banks. The Nkanu territory is crisscrossed by numerous rivers, streams, and rivulets, all

Fig. 1 Nkanu region

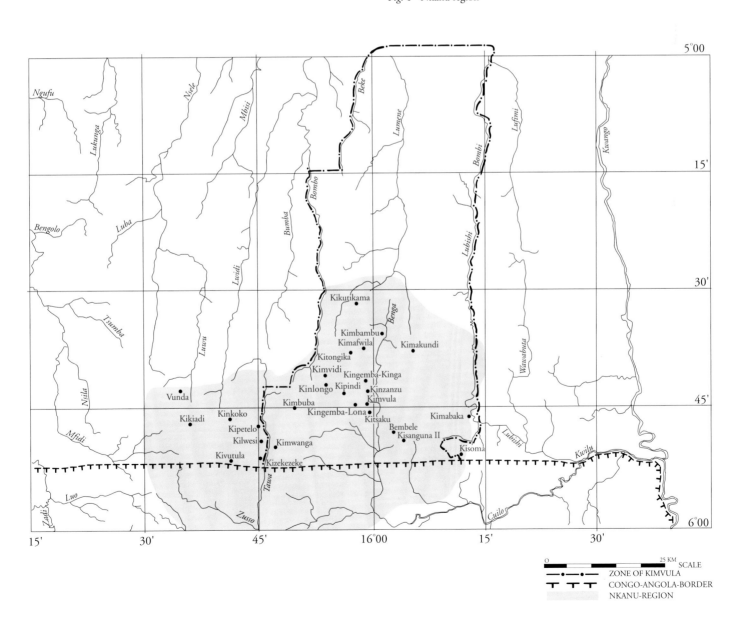

of which are impossible to navigate because of their meandering courses and many waterfalls.

The average temperature in the region is 64° F (18° C) and the average rainfall is 1591 mm. The rainy season, which arrives in mid-September and lasts until the end of May, is interrupted by a short dry period from mid-January to the middle of March. The dry season lasts from the beginning of June until the middle of September.

An agrarian society, the Nkanu once located their communities, consisting of ten to fifteen rectangular buildings, in or near the forest, which provided them with both raw materials and food. Now they establish their communities along roads to facilitate trade with merchants.

In Nkanu communities, the savanna, woods, palm groves, and rivers are collectively owned by clans, whose members enjoy property rights. Farmland is established some distance from the village in cleared forests or on the savanna, where small livestock roam freely. The already rather fertile red sandstone is further enriched by a layer of ash, a result of the slash-and-burn technique of farming.

At most, farmers sow two crops on a plot of land before cultivating a new field. Clearing the land and burning the brush fall to the men in the family. The women and children sow, weed, and harvest the crops, which include manioc (a versatile tuberous plant) and sesame. Sweet potatoes, yams, groundnuts, beans, corn, melons, and rice as well as bananas, pineapples, mangoes, and various citrus fruits are grown to a lesser extent. Nkanu women sell their surplus crops at the local markets.

The Nkanu augment their diets by hunting, fishing, and gathering food in the wild. Although bush fires and intensive hunting have depleted the once abundant wildlife of elephant, buffalo, hippopotamus, lion, and wild boar, the Nkanu hunt small antelope, feline predators, pangolins, birds, and small rodents, and gather caterpillars and crickets. Small livestock (goats, chickens, guinea fowl, and, in rare cases, pigs) are considered an investment and are limited. These animals are reserved as payment for certain rituals (e.g., healing) or serve as dowry payment.

The artistic and craft traditions of the local artisans declined with the introduction of Western materials and products. No longer are the sleeping mats, raffia cloth, baskets, and household items of the artisans in demand within Nkanu communities The local smith and wood sculptor, on the other hand, do enjoy a more prolific livelihood and higher status within the traditional Nkanu community.

In the past, every chief and practically every village had a forge. Today, blacksmiths not only make tools, weapons, and clan insignias, but direct the installation ceremony of the chief, pass judgment on disputes (by consulting the *kisengo* oracle), and treat illnesses related to the *nkisi lufu* ("the power of the forge"). Woodcarvers make handles for tools, power symbols, such as flywhisks and staffs, for the traditional chief, and the

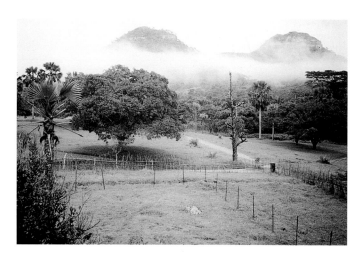

Fig. 2 View of Kimvula in the vicinity of the former Franciscan monastery. Kibandala mountain is visible in the distance. 1990

necessary power objects for local healers and diviners. More specialized woodcarvers are ritual specialists (*nganga luvumbu*) who have a major role in the boys' initiation rites.

Nkanda art and ritual today

For cultures throughout the world, the passage from childhood to young adulthood is celebrated as a significant event in one's life. The Nkanu ritual is a rich and complex rite called *nkanda* (also known as *mukanda* in other central African cultures), which is observed at puberty. During initiation, boys guided by sculptors and ritual specialists create a distinct art form that is unique among the traditional arts in central Africa.

The phrase "traditional African art" frequently conjures up images of somber-colored masks and sculptures heightened by a rich patina. The woodcarvings of the Nkanu peoples (and that of their neighbors, the Yaka), however, tend to deviate from this common picture. The symbols, patterns, and colors embellishing the brightly polychromed wall panels, sculptures, masks, and head posts convey a secret language that is shared by the specialists and initiates participating in *nkanda*.[2]

Although the polychrome surface decoration adds to the visual impact of the masks and sculptures, the use of color and decorative patterns primarily serve to carry a message. The human and animal sculptures also have a particular meaning, as do their gestures. Deciphering these symbols was a principal goal of the field research I undertook in 1990–91.[3] I am indebted to the numerous Nkanu men and women who welcomed me into their communities and gave so much of themselves. Their contributions enabled me to unlock the information hidden in the art of *nkanda*.

Principal among my teachers were three professional sculptors—Nsiabula Malungidi, Marcel Kahuma, and Batata

Mutombo—who sculpt in the traditional style, creating works for local patrons who need objects in their healing practices (figs. 3 & 4). Their initiation-related objects are generally destined for rituals that take place in northern Angola, as *nkanda* is rarely observed in the Democratic Republic of the Congo nowadays. They also sell their works to traveling merchants, who in turn sell the items at art markets in Kinshasa, the capital of the Democratic Republic of the Congo.

Marcel Kahuma and Batata Mutombo, in particular, taught me a great deal about *nkanda* and its art. Both men were afflicted with a medical disorder and consulted a diviner. The diviner who Marcel Kahuma consulted revealed that his deceased grandfather was a circumciser and woodcarver and had chosen his grandson as his successor. Kahuma was trained in Kinsuni, an Angolan Nkanu village, and, to this day, performs circumcisions, sculpts, and makes drums to order for diviners. Batata Mutombo was trained by his grandfather to be a healer and woodcarver. According to Mutombo, he learned about the qualities of different kinds of wood, the use of his tools, and how to make various sculptures by watching his grandfather make small sculptures for initiation rituals.

The assistance of two ritual specialists *(banganga baluvumbu)*, Domingiele Mvwaka and Ignace Mayimuna Magebuka, was also invaluable (figs. 5 & 6). Although they no longer work as artists, they made several initiation objects so that the production process and attendant ritual could be documented. The artistic skills, collective memories, and interpretations of all these and other Nkanu elders have resulted in a better understanding of the creative intentions and symbolic content of the artistic traditions associated with *nkanda.*

The goal of *nkanda*—to educate Nkanu youth and ensure the procreative powers of the initiates—inspired the sculptors to create and present images of human and animal sensuality with humor and a penchant for satire. The Nkanu believe there is a link between one's own life cycle and the movement of celestial bodies. In order to gain control over this cyclical process and, thereby, enable a smooth transition from childhood to adulthood, power objects are used within the context of the ritual. These sculptures ward off malevolent forces and sorcerers and accompany the initiates until their rebirth at the end of *nkanda.*

The arrival and influence of Christian missionaries, the spread of new ideologies, and the activities of religious movements greatly affected the impact of local customs and the context in which ritual objects functioned.[4] Combating local traditions, the missionaries considered the *nkanda* a pagan ritual and persuaded parents to have their boys circumcised in the local dispensaries.[5] Several other religious sects also sought to ban the practices of local specialists, confiscating and burning ritual objects. Because these messianic movements presented themselves as Christian, the colonial government tolerated them at the outset. Once it became clear these movements, which were interpreted as being anti-Western and having a political agenda, were mixing Western and African religious practices, the government persecuted their prophets and followers. How deeply these events affected the tradition and ritual practices of the Nkanu is difficult to estimate. It is certain that local specialists, carvers, and healers, fearing reprisals, did stop working—some temporarily, some permanently.

Until recently, undergoing circumcision and subsequently participating in the *nkanda* ritual was required for any pubescent Nkanu boy. Today, *nkanda* is practiced sporadically by the Nkanu living in the Democratic Republic of the Congo. The last known *nkanda* to take place in the area of Kimvula was in 1945–46. More recent puberty rites in the 1970s and 1980s were organized in the Congo-Angola border region.[6] Congolese

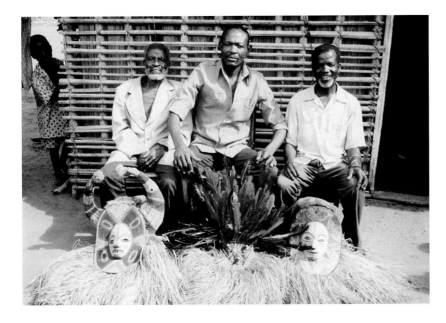

Fig. 3 Nsiabula Malungidi, Marcel Kahuma, and Mbala Malandula, 1990

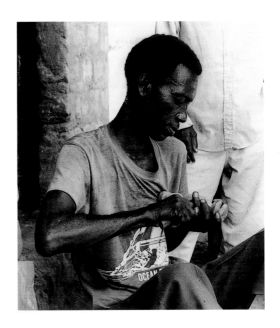

Fig. 4 Batata Mutombo, 1990

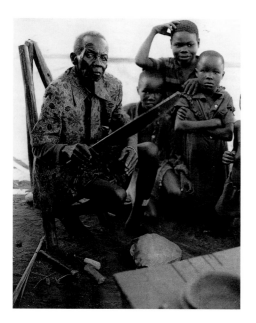

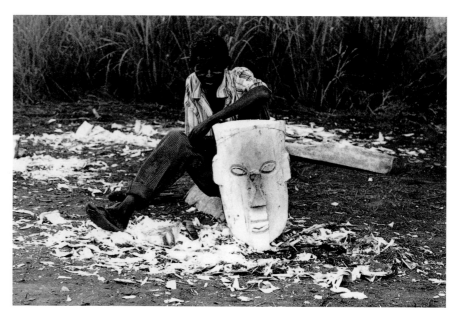

Fig. 5 Domingiele Mvwaka, 1991

Fig. 6 Ignace Mayimuna Magebuka, 1991

Nkanu parents often send their boys to be initiated in Angola, but sometimes they prefer to have their sons circumcised when they are just a few months old in a short ritual known as the *mukanda mu gata,* the "*nkanda* in the village."[7]

In the 1970s, some Nkanu youth formed the group Bakima and tried to turn the *nkanda* and its masked dances into folklore events. They acquired objects used in previous *nkanda* rituals and ordered some masks from an Angolan woodcarver. When two individuals died under suspicious circumstances, however, the ensemble disbanded. In 1989, a group of Nkanu intellectuals formed the Alliance Culturelle de Kimvula. They linked their cultural activities to a socio-economic program, aimed at the mechanization of agriculture in the Kimvula zone. They, too, had to suspend their activities because the leader was accused of bewitching people with the new masks he had ordered.

Nkanda ritual process

An individual's passage from childhood to young adulthood is a momentous occasion marked by celebration in cultures throughout the world. Although all rites of passage exchange one stage of life for another through the symbolic death and rebirth of an individual, the ceremonies and the names used for the different rituals are as varied as their organizations and designs. The *nkanda* ritual as practiced by the Nkanu and other peoples of central Africa is an exclusively male affair that begins with the circumcision of the neophytes.[8]

Before the ceremony, a boy is regarded as an immature person without a voice. Afterwards, he is accepted as a full and responsible member of the community. The ritual is a significant event for the community also, for it announces the

education of a new generation of adults who will safeguard the community's traditional customs and ensure the continuity of society through their procreativity. The Nkanu consider infertility among the worst afflictions to beset a person; consequently, barren individuals are not considered full members of the community. Because malevolent forces—spirits and anti-social human beings (the so-called sorcerers)—may interfere during *nkanda*, the ritual and its organization are strictly controlled by specialists who have a variety of aids, including masks and sculpture, to combat any force or obstacle that may impede its successful completion.

Often, it is the boys or their parents who inform the chief and representatives from neighboring communities and quarters that they are ready for an *nkanda*. Aspiring initiates may be anywhere from six to eighteen years of age. Those who are ill may not participate because the boy must be strong enough to undergo circumcision and the period of seclusion. Reputed sorcerers are warned and explicitly asked to refrain from any antisocial behavior before entering the ritual site so as not to contaminate the initiates and defile the *nkanda* proceedings. If they do not heed the warning, the protective spirits within the *nkanda* enclosure meet the sorcerers with deadly force.

A boy taking part in the ceremony will offer each maternal and paternal uncle a gourd or a bottle of palm wine. In return, he is given a chicken, a goat, and some palm wine as a gift of encouragement. His father gives him a chicken, a goat, or a piece of game, which will be eaten on the eve of the circumcision ritual. The ancestors also have a voice in the organization of the ritual. Relatives of the prospective initiates set up a collective hunting party: a good hunt is interpreted as a sign that the ancestors agree with the planning. If the hunt is poor, the relatives try to discern why the ancestors are dissatisfied and win their approval.

Nkanda usually begins at the end of the rainy season, around the middle of May. Older initiates prepare the initiation enclosure *(kimpasi ki nkanda)* where the circumcised boys *(kikumbi,* pl. *bikumbi)* will stay for a period of time. At one time, the boys remained in the enclosure from one to three years, depending on the resources available to assure their livelihood. Today, the period is much shorter.

The *kimpasi* (figs. 7 & 8) is situated in a clearing in the woods some distance from the community and close to the river. A fence of palm leaves encloses the *kimpasi* to prevent the uninitiated men, boys and women from observing the initiation rites. An S-shaped, ten-meter-long corridor that opens onto an inner courtyard is built at the entrance to protect the secrecy of the rites from the uninitiated and to prevent small whirlwinds, which could carry dry leaves—and thus, malevolent spirits—from blowing into the compound. Two side gates lead to the *mazemba,* a shaded area where the boys are seated shortly after they are circumcised.

At the gate *(kikalakala)* to the entrance two large figural sculptures *(biteki zi makanda)* representing a man and a woman with accentuated genitals are positioned across from one another. On the road *(nseyi)* leading from the enclosure to the village stands the *kala di Kakungu,* a post crowned with a sculpted anthropomorphic head, which warns travelers that the road is no longer accessible to the uninitiated. One or more structures *(nzo nkanda),* shaped like a house without doors, are built within the walled enclosure depending on the size of the group of initiates. In the courtyard a wild fig tree and a shrub grow and a fire is maintained day and night.

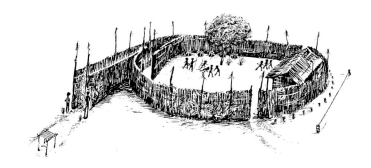

Fig. 7 Drawing of *nkanda* enclosure

A number of ritual specialists are invited to lead the initiation. Each family chooses a specialist *(nganga kitapa)* who will perform the circumcision on their boy. Another specialist, the *nganga luvumbu,* performs several tasks within the *nkanda:* he is a healer of fertility disorders and the *nkanda* woodcarver. He works within or near the enclosure and carves the wall panels, sculptures, masks, and head posts. He is also responsible for installing protective defenses against sorcerers.

Fig. 8 Nkanda enclosure where newly circumcised boys undergo *nkanda* initiation

Key **1.** road block *(kikaku);* **2–3.** *biteki zi makanda;* **4–9.** unsculpted poles *(nsinda);* **10–12.** gates *(mahitu);* **13–14.** sculpted poles *(makala);* **15.** stone of Mbala *(tadi di Mbala);* **16.** *n'sanda* tree; **17.** *kombasesa* shrub; **18.** *futi* liana (tied between two stakes or trees); **19–39.** termite hills *(bikuku);* **K:** Kiala's place; **Ma:** Makengo's place; **Mb:** Mbala's place

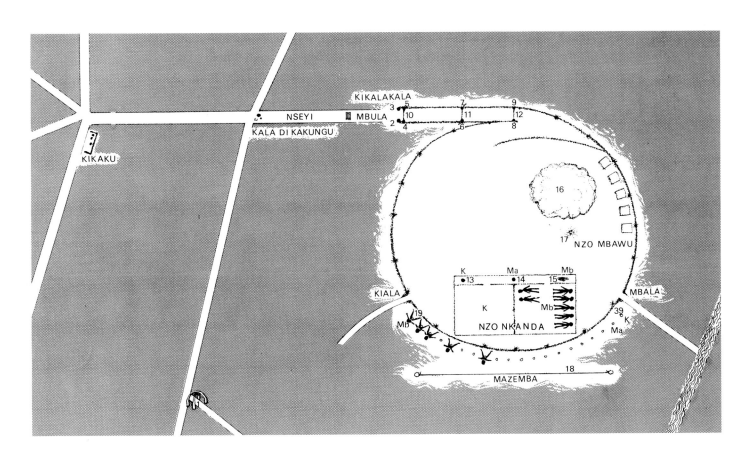

Older initiated men *(kilombosi,* pl. *bilombosi)*[9] guide the initiates, supervising them during circumcision and bathing in the river. They teach them *nkanda* dances and a variety of manual skills, including how to make and set traps and how to make baskets and sleeping mats. They also dictate the rules of life within the *kimpasi* and punish the boys when necessary.

A sterile or post-menopausal woman who cannot jeopardize her own fertility or that of the circumcised neophytes holds the title of *kifika* and is responsible for supplying food to the initiates. Prepared food is placed on a raised platform *(mbula)* located four or five meters from the entrance of the initiation enclosure.

In the early afternoon all the prospective initiates gather together with their *bilombosi* in a single house to share a meal. For the first time, the group's size (which can very widely, from eight to thirty-five) becomes apparent. On the eve of the circumcision ceremony, each *nganga kitapa* takes a bite from a bunch of leaves, puts a cola nut and some palm wine in his mouth, chews everything and spits it out onto the navel, back, and forehead of the boy he is to circumcise. Then, with a whip made from twigs, he strikes the boy three times on the palm and back of each extended hand.[10] From twilight until late at night and the following morning, initiates from the surrounding villages and the community that organized the *nkanda* entertain the future initiates. They use cylindrical dance drums (fig. 9) to accompany their songs and the various initiation dances (fig.10).

The next day, upon a signal from the forest, fathers, brothers, or uncles run with the boys on their backs to the *kimpasi.* The bravest boys, however, get there under their own power. Once a boy reaches the entrance to the enclosure, he unties his loincloth and stands before the circumciser with his legs slightly bent or straddles a tree stump with his legs spread and his pelvis tilted. After circumcising the neophyte, the circumciser plants a tuft of grass on the spot where the blood seeps into the earth. The other initiates will be circumcised on the same spot as the first so as not to bring misfortune to the *nkanda:* it is believed that the sand with the blood from the circumcision could be used by a malicious person, resulting in the death of the boys.

The newly circumcised boys are given new names.[11] The first boy to present himself for circumcision is called Kiala; the second, Makengo; the third, Kabuiko; and so on. The last boy to be circumcised bears the title Mbala.[12] They are then led to the *mazemba* and seated in a half circle (see fig. 8). At his place each initiate will find a black mushroom-shaped termite mound, underneath which are hidden anti-sorcerer "projectiles." The circumcised penis is placed on the termite mound, which absorbs the blood.[13]

Inside the *mazemba,* the elders enumerate the foods the initiates are forbidden to eat and the rules they are to follow. The initiates are not permitted contact with women or the uncircumcised, under any circumstance, for as long as they

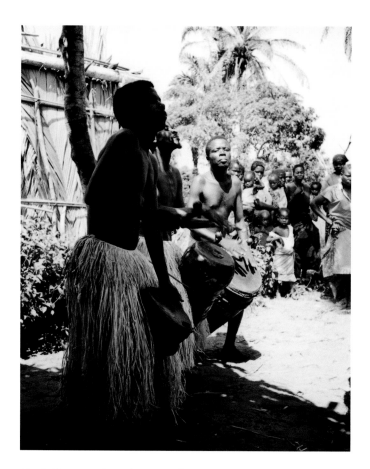

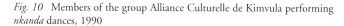
Fig. 9 Drummers from the group Alliance Culturelle de Kimvula, 1990

Fig. 10 Members of the group Alliance Culturelle de Kimvula performing *nkanda* dances, 1990

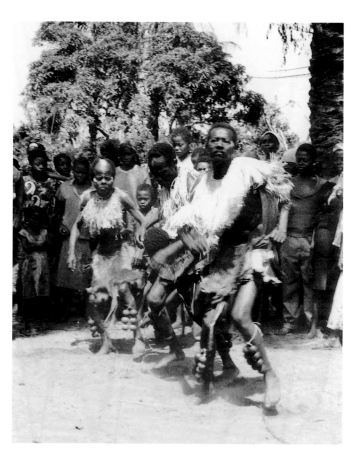

Fig. 11 Boys performing
nkanda dance, 1990

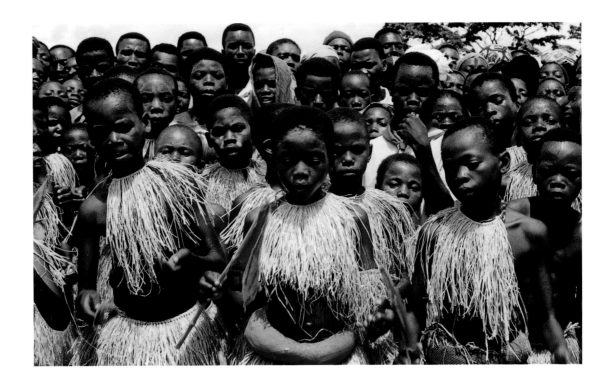

remain in training; when outside the initiation enclosure they can only communicate with each other, when necessary, by whistling. They must use an esoteric language for words that must not be spoken.[14] Everything is done collectively. Close friendships among the initiates are encouraged. Exchanging insults, arguing, or fighting are all subject to punishment. Disobedience towards an elder is not tolerated.[15] The initiates may not leave the enclosure without the permission of an elder. Running away from the enclosure or talking to an outsider about the rituals is subject to severe, corporeal punishment.

When the bleeding stops, every boy declares an oath before being assigned to his definitive place within the initiation enclosure. While tying a knot in a liana, strung between two stakes or trees, each initiate repeats *"Ntieti mbinza nsala zi kileki, mambu ma kimbuta. Ngingi!"* ("Swallow, the feathers of childhood, the business of the elders. Ngingi!"). In other words, although they still appear young, they now have the knowledge of adults. Into the knot, they symbolically tie their own procreative powers and their own lives, which they will forfeit should they violate the *nkanda* rules. A small piece of the foreskin is placed in a piece of cloth and tied around each boy's hip as an amulet. Before leaving the *mazemba*, the ritual specialist buries the remainder of the foreskins along with the termite mounds.

Within the enclosure, the elders split the group into smaller units, assigning the initiates a place of their own.[16] Eating, sleeping, and participation in various activities all happen within one's own group. The day after being circumcised the boys rest. Palm oil is poured onto the wound to ease the pain and stimulate the healing process. Early on the morning of the third day after the circumcision, the elders accompany the boys to a place the villagers use for crossing or washing in the river. An elder, wearing the Nkoso mask, speaks to the spirits who live in the rivers or on the banks, after which the circumcised sit one by one in the river facing upstream.

Once the wound has been cleaned, an elder puts a young *n'titi* leaf[17] on the penis to seal off the wound completely and shows the initiate how to tend to his wound until it is healed, which takes about a week. When the wound has healed, the boys put on a fiber loincloth or their everyday clothes and rub their bodies with kaolin.

During the rest of their stay at the initiation site, the initiates continue to learn. They develop skills such as clearing fields, cultivating new fields, making and laying traps, making baskets, sleeping mats, fish traps, and so on. They learn parables, songs, and dances, some of which they will use to liven up the departure celebration. The songs convey information about the different kinds of masks and the boys' lives as future married men. Some of the songs are erotic and are intended to stimulate the initiates' libidos, while the male and female guardian figures with accentuated genitals at the entrance to the enclosure serve a didactic role.

The moment the boys are ready, the elders send them out to hunt, set traps, or work the fields. The first large animal to be caught by an initiate is called the *mbisi nkungu* or *nkungu menga* ("the game/the blood of purification"). This is said to be a sacrificial offering to restore the blood that was lost during circumcision.

As soon as the initiates know their dance steps and song lines, the *nganga luvumbu* is invited to begin carving decorated wall panels, figurative sculpture, and masks. Initiates may order specific masks from him.[18] The finished masks are kept within the enclosure, in a small structure *(nzo mbawu)*[19] until the day they are used.

As the end of *nkanda* draws near, a ritual meal of hen and manioc pudding is prepared in the village by the *kifika*. Although this meal is generally reserved for the three leaders among the initiates, they can choose to pass on the privilege to the three youngest initiates. Dancing and singing, their bodies blackened with charcoal, they head for the community. There, they eat quickly and take the rest of the food back to the enclosure, where the other initiates await their return.

Nkanda closing ceremonies take place in three stages. During the first phase of the closing ceremonies,[20] the *kikaku* is built at a busy crossroads between the *kimpasi* and the village (see fig. 8). The *kikaku* is a three-sided structure that serves as space to display the wall panels and sculpture which were created during *nkanda*. Passersby who see the *kikaku* know the *nkanda* is drawing to a close. Upon bathing in the river, the initiates decorate their bodies with red pigment in front of the *kikaku*.

Before *nkanda* concludes, a collective hunting party is organized. No animal on the list of forbidden foods may be caught. A successful hunt indicates the ancestors agree with the closure of *nkanda*. The meat is prepared for the next day's feast. On the eve of the departure celebration, a dance—during which each initiate demonstrates his agility and dancing skills— is held (fig. 11). Those who excel will dance with a mask the next day.

The departure celebration usually starts late in the afternoon. The boys, their upper bodies covered with red pigment, wear dancing skirts made of raffia, knit shirts or *masamba* fibers crossed over their chests, ankle bells, and raffia garlands around their necks.[21] In their hands they carry a rattle or wooden sword or staff. The mask is put over their head. Fully dressed, the newly initiated appear in the village.

The masked dancers perform in pairs, Nkoso and Kisokolo first. The order of performance for the other masks depends on the organization of the *nkanda*. To the great amusement of the audience, those who wear animal masks imitate the behavior and sound of their respective animals. Kakungu is usually embodied by Mbala, the oldest initiate. He is the last to

appear and dances like no other. Disguised as Kakungu, Mbala runs back to the enclosure and changes disguise. Mbala's dances are well known for their obscenities. Often, the initiate hides a cylindrical piece of wood or a manioc root representing an erect penis under his skirt. During his performance, he suddenly takes it out and thrusts his hips in the direction of the women present. Some women respond by assuming sensuous postures themselves. During the celebration the audience sings songs to accompany the different masks. To encourage and reward the dancers, they put paper money in the boys' mouths. After the song and dance, the boys and their escorts return to the enclosure.

When the boys depart the *nkanda* they receive a new name to acknowledge their adult status. Back in their communities, the boys spend three days under the wild fig tree that grows in every square, mimicking the animals they represented as masked dancers. They must spend the night with a woman; if married, they stay with their wives. It is the woman's task to ascertain whether the boy is capable of intercourse. If not, he will be treated by the *nganga luvumbu*.

The second phase *(kutumba)* begins when the boys embark on a dancing tour[22] to collect money to pay the ritual specialists and make arrangements for the final stage of initiation.

On the day the *nkanda* definitively ends, the boys hurry back to the enclosure. There, they leave their dancing costumes. By nightfall the shelter is set on fire, while the forces present remain in the enclosure. The boys must not look back as they leave the area. Once they reach the village, they gather in a hut and are entertained by the elders until the fire has died out.

The next day, the new initiates are brought to the river. The old loincloths are exchanged for new clothes. They are escorted to the marketplace to receive gifts and steal all kinds of things, which they give to the ritual specialists. Afterwards, they eat a final meal—which includes several of the forbidden foods—together in the village, thereby lifting the food ban.

The boys return home after the meal and behave like perfect strangers, pretending not to recognize their once familiar environment. Slowly, they take up their responsibilities within the community. Now they can think about starting a family.

Notes

1 In addition, Nkanu peoples also reside in a number of larger centers, such as Sacandica, Icoca, Quimbele, Béu, Cuilo Futa (Felgas 1960: 24; Felgas 1965: 24, 26; Mesquitela Lima 1970; Pélissier 1986: 273). The most recent census figures from 1948 (Boone 1973: 159) and 1965 (Felgas 1965: 24, 26) list the population as 58,000. More recent census information is not available. The territory in Lower Congo lies between the Taw and Lubishi rivers. In the north, the Nkanu can be found as far as the Kutu (a tributary of the Lumene River). In Angola, the Cuilo River is the eastern and southern border, while the Béu is the western boundary.

2 It is difficult to develop a complete "reading" of *nkanda* wall panels and interpret the intentions of the artists who created the work and the meanings they sought to convey. Each human and animal figure adopts a particular posture or pose and each individual polychrome design has symbolic meaning. The colors employed also imply different meanings and qualities. These elements are not presented independently but in combination with other figures and other designs and, thus, it seems likely that there is a narrative and symbolic connection between the various figures and designs. Moreover, a wall panel is not an independent work of art but is integrated along with other panels into a sculptural composition with additional figural sculpture that is placed in front of the wall panels in the *kikaku*.

3 The author conducted field research in 1990 and 1991 among the Nkanu peoples, Kimvula Zone, Democratic Republic of the Congo. Information was gathered by interviewing men and women who participated in *nkanda* rituals, asking them to interpret photographs of Nkanu objects in Western collections, and recording the creation of a mask and wall panel by two ritual specialists. The research was published in a doctoral dissertation, "*Beelden, maskers en initiatiepanelen bij de Nkanu en hun buren, de Mbeko en Lula. Socio-culturele context en stilistische analyse (Zone Kimvula, Congo),*" Universiteit Gent, Belgium, 1998.

4 The Jesuit mission at Kimvula was founded in 1926. The Jesuit fathers were joined by the Franciscan sisters in 1934 and the Brothers of Lourdes in 1940. The mission was left to the care of the local clergy—Frères de St. Joseph, Soeurs de St. Marie—at the end of the 1970s.

Documents dating back to 1921 mention several sects and prophets active in the region: Katungi, (Ma)Tonsi or the sect of the prophet Ngunza (also known as Mvungism, after the followers, BaMvungi), and the Dieu-Donne sect (also known as Mbundu Yezu or Mabwa). In the villages they visited, they went from door to door to confiscate ritualistic objects. Art dealers made use of the services of these people to collect objects.

5 Father P. Davister recorded in his diary: "Thursday, June 9, 1937: [. . .] by some lucky chance [. . .] children have been taken from a circumcision ritual; 37 in one go; have had them operated in accordance with local customs. Monday, June 14, 1937: a second group of circumcised boys; 13 followed the first 37, a total of 50. Deo Gratias. A victory over paganism?!"

6 While conducting field research, I was told that an *nkanda* was to be held in 1993 near Bembele in the southern Congolese Nkanu area.

7 The removed foreskin is wrapped in a bundle of *nlolo* leaves and is buried by the specialist at the foot of a *kilolo* tree. This tree is said to stop the bleeding of the wound, because it preempts the anger of the ancestors. Palm wine is poured on the spot. If the sand absorbs the liquid immediately, this is interpreted as a sign that the ancestors are inspired to kindness.

8 I prefer to use *nkanda* instead of *(nzo) longo* (Van Wing 1920–21, 1938, 1959) for the circumcision ritual among the Ntandu, Mbata, and Nkanu. The Nkanu use the first word to refer to the "rite de passage" as it is described here (and as it was adopted from the Yaka/Luwa), whereas *longo* stands for the ancestral custom and is now used for the act of circumcision itself, without the comprehensive ritual context.

The *nkanda* ritual is known under the same name or a phonetic variation *(nkanda, nkaanda, nkha(a)nda, mka(a)nda* or *muka(a)nda)* among several ethnic groups. According to Mudiji-Malamba (1989: 55(67)), the *nkanda* still exists in an area bordered by the Kwango, Kasaï, and Upper Zambezi rivers. Among the Kuba peoples, Jan Vansina (1993: 244) locates the *nkanda* east of the Kasaï River. None of the peoples within this region claim to have originated the ritual. In the literature, we find several theories about *nkanda's* origins. Plancquaert (1930: 59–60) refers to the sources of the Kwango, Wamba, and Kwenge rivers; White (1953: 42) mentions Shaba region; Vansina (1993: 244) suggests the sources of the Kwango and Kasaï, an area known as "Serra de Musamba," from which he thinks the ritual spread since 1400. The Lunda and Luwa played an important role in spreading the *nkanda*. I believe the origin of the ritual now known as *nkanda* lies with the Nsamba population. The same is true for the principal mask forms.

9 These elders are also called *bankaka, bankayi, bitati,* or *bitadi:* grandfathers.

10 The *ngunda* and *kusengula* ceremonies are believed to strengthen the back of the initiates and, therefore, increase their sexual potency. *Kusengula* means raising.

11 *Nkanda* names must not be spoken out loud. The boys may use whistles or rhythmic drumming on the *mondo* drum to call one another. When the boys rejoin the community, their *nkanda* names are often added to their first names or nicknames. It is an honorary title to indicate that they have been initiated in the traditional way and sometimes to maintain the leadership position they occupied during *nkanda*. Boys who went through *nkanda* together often continue to use their *nkanda* names with one another.

12 Sources also mention a list of names assigned in random order. The eldest candidates are most often chosen to be Kiala, Makengo, Kabuiko, and Mbala because of their leadership qualities and virtuous conduct. The honorable position of Mbala is usually reserved for the son of a chief or dignitary. He is often also a very good dancer.

13 Manioc bread, made by the *kifika,* is handed out to the initiates. The *nganga luvumbu* dips a piece of the manioc in the blood from each boy's wound. The pieces are passed among the boys. According to my colleagues in the field, eating each other's blood speeds the healing process and seals the bond between the boys who are being initiated together. The penis is then supported with a piece of wood *(koso di nsiesi)* or foot of the *nsiesi* antelope, which is tied around the waist with a raffia string.

14 The genitals, for example, are called *moyo wu bantu,* "the life/soul of human beings."

15 The Nkanu expression *"Kulemfuka ka Kwanyi ko"* declares "Obedience doesn't render a man a slave."

16 The group of initiates is usually divided into two smaller groupings. The elders select two initiates to serve as leaders; their titles are Mbala and Kiala. If the group of initiates is very large, the initiates may be divided into four smaller groupings with two additional initiates selected to hold titled positions. The two additional titleholders would be named Makengo and Kabuiko. The other nontitled initiates refer to these titled individuals as chiefs or *bamfumu.*

17 A bundle of *n'titi* leaves is wrapped in a *kibunda-bunda* leaf and put under the glowing embers of an open fire to make them supple and warm. The result is called *ndamba;* the act, *bavumbidi ntiti* (v. *kuvumba*).

18 Some of the masks—such as *Nkoso, Kakungu, Kisokolo,* and *Makemba*— are always made.

19 In these specially built enclosures, the masks are stored according to a fixed order: Kisokolo is put on top of Kakungu; Makemba is kept in a separate hut. Smaller masks are stored in threes and fours. Leopard masks are placed on top of goat masks, thus, enacting a scene in which the goat is devoured by the predator, a popular theme among sculptors of *kikaku* wall panels.

20 The first stage is called the *kuyol Nkoso* or *kuyobila ku nkanda. Kuyola* or *kuyobila* means "to wash (themselves)."

21 Nkanu masked dancers wear a dancing skirt made of antelope hide, a buffalo hide belt, and a gray monkey hide attached to the front of the skirt (Plancquaert 1930: 102 (1)).

22 They obtain their dancing costumes, masks, and drums from the *kimpasi* and tour the neighboring hamlets and communities to provide entertainment. This activity may last from two to three years.

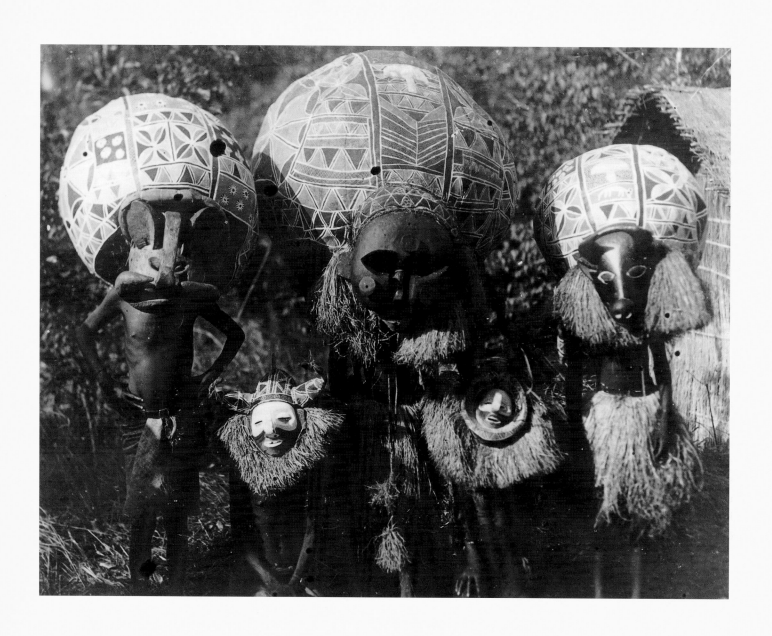

The art of nkanda

Annemieke Van Damme

The corpus of extant Nkanu art related to *nkanda* initiation rituals is small and includes the important collection of Nkanu objects in the Africa Museum, Tervuren, Belgium. A number of these are among the earliest objects to enter the museum's collection in 1903. The collection of the Jesuit Fathers of Heverlee, Belgium, also includes important Nkanu objects, which are now on permanent loan to the Africa Museum, Tervuren. Nkanu objects can also be found in the collections of the Broeders van Lourdes (Oostakker, Belgium), the Sociedade de Geographia de Lisboa (Portugal), Musée de l'Homme (Paris, France), the Africa Museum, Berg en Dal (Netherlands), and the Institut für Ethnologie der Universität Göttingen, Abteilung Völkerkundliche Sammlung (Göttingen, Germany).

Literature on African art rarely discusses the art of the Nkanu.[1] When it does, the same objects are illustrated—the Tervuren figure of a drummer (cat. 19) or the Kakungu mask from the Institut des Musées Nationaux de Congo in Kinshasa (inv. no. 70.6.721).

Nkanu wood sculpture is generally considered to be of a low technical quality. Undoubtedly, this perception has contributed to the lack of attention devoted to Nkanu material culture, as has the poor cataloguing of Nkanu sculptures in museum collections. Most of the objects classified "*nkanda* sculptures" entered Western museums in the first half of the twentieth century, when collection documentation was often imprecise. As a result, Nkanu objects were misidentified as Yaka or Kwango in origin.[2]

The Nkanu objects in the catalogue compose a homogeneous grouping: they were all carved from the same kind of wood and lavishly polychromed. Sculptors carve *nkanda* sculptures from the wood of the umbrella tree *((ki)ngela)*,[3] which is soft and very light when dried, allowing the sculptors to make fairly large wall panels, figurative sculpture, and masks.

Nkanda art is classified by its distinct appearance and specific function within the context of *nkanda*. Strict classifications, however, seem superfluous at times when the high relief figures carved on the wall panels are elaborated in much the same way as their three-dimensional counterparts. In some panels, the figures appear ready to step out of the flat surface: arms and legs often projecting away from their bodies, while the feet remain firmly attached to the painted background.

Although Nkanu objects often look rudimentary or sketchy at first glance, those parts of the body that the sculptor wants to draw attention to are usually quite detailed and often considerably enlarged. Because umbrella wood is easily carved some artists experiment with the representation of movement or complex postures while other sculptors separately carve body parts, which they attach to the figure's torso with wooden pegs. Polychrome decoration is then added to create the desired intricate detail.

The colorful surface painting and numerous patterns created by *nkanda* sculptors lend a dramatic and celebratory character to Nkanu art. Literature on African art has characterized Nkanu art as "folkloristic" in contrast to the classical works[4] of traditional African art. Joseph Cornet notes: "Despite certain artistic elements, most of this initiation sculpture must be considered of folkloristic importance" (1972: 82). *"Folkloristic,"* without its pejorative connotation, can be employed to describe these objects, considering their sometimes schematic design, colorful appearance, abnormal body proportions, and satirical depictions. These are objects that are made and used within the context of initiation rituals, in contrast to refined royal art, but they are certainly not amateurish.

Most *nkanda* art is created for public display near the conclusion of initiation. Wall panels adorned with painted human and animal figures carved in high relief are installed on the interior walls of the *kikaku,* a three-sided roofed structure placed at a crossroads outside the initiation enclosure. The *nganga luvumbu* also carves a number of smaller figural sculptures to be placed inside the *kikaku* (cats. 11, 16–19, 21, 22). According to informants, the subjects selected by the sculptors are meant to evoke a particular scene or allude to an event that took place during the *nkanda* session.

Among the freestanding sculpture made for initiation, a large male and a female figure are placed at the entrance to the *nkanda* enclosure (cat. 20). Head posts and a variety of masks are also produced and function within the context of *nkanda*. Informants described some male or female figures as power figures. An *nganga nkanda* may place these sculptures or a miniature post inside the initiates' quarters. The *makala* are also believed to cure problems caused by the *nkisi nkanda* (malevolent spirit) and may therefore be placed inside the home of someone with fertility problems.

The photograph by A. Mahieu in 1905 documents a *kikaku* displaying decorated wall panels and figural sculpture (fig. 12). The wall panels at the back of the *kikaku* include

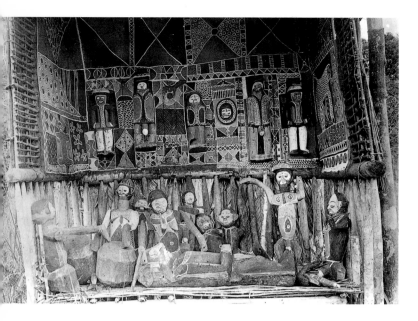

Fig. 12 Wall panels and sculpture displayed inside a *kikaku* enclosure
Photograph by A. Mahieu, 1905
Archive photograph, Africa Museum, Tervuren

depictions of three Congolese figures with pronounced genitals wearing Western-style clothing, two Europeans and one Kisokolo mask. The two Europeans, with arms at their sides, wear colonial helmets, and are decorated with a herringbone pattern between the lapels of their jackets (pointing to contact with the spirit world?). Elaborate surface patterning decorates the panels. A number of fields filled with floral designs represent the female principle. Along the entire width of the top of the panels, large painted compartmentalized triangles represent crossroads, barriers, or contrasts (man/woman). The European figure on the left is depicted standing on a cross-shaped symbol. Scaly patterns representing a leopard or other feline predator are painted on the main wall panels at the back of the *kikaku*. Felines and their spotted skin refer to traditional leadership. Side wall panels are also decorated with spotted felines—one is drawn in profile while the other is depicted as a stretched animal skin.

Freestanding figures displayed in front of the wall panels represent a single narrative scene. On the left side of the photograph, two figures hold sticks and play spherical *masikulu* drums. The figure of a woman is positioned leaning over a recumbent figure in the center foreground. Is she mourning her dead husband? This scene may refer to an event that took place during the initiation rite, to the death of a dignitary in whose honor the musicians have come to perform. Two additional figures with raised arms are discernable in the right-hand corner of the photograph. The taller of the two figures is possibly holding a cola nut in his hand. When a chief dies, his power is "captured" with a piece of kaolin *(mpemba)* and redwood powder, which are placed in his mouth. The pigments are then replaced with a cola nut. Note that several of the figures have pronounced navels: the navel is symbolic of one's connection with the clan.

Nkanda wall panel themes

Nkanda art depicts both Congolese and European men and women and animals in relief on wall panels and in freestanding figural sculpture. While each figure tells its own story through the details of its clothing, posture, gesture, and colorful and multipatterned surface decoration, the relationships between the elements and their multiple interpretations relate a broader narrative. I have attempted to interpret the meanings sculptors wished to convey through these elements by showing Nkanu informants photographs of *nkanda* art in Western collections. Their comments and the concepts and expressions they used while examining the photographs helped clarify some questions.

Nkanu artists, for example, distinguish their Congolese and European subjects by variations in skin tone, facial features, dress, and posture. Europeans are generally painted in pink, ochre, or orange pigment. The faces of Nkanu figural sculpture are usually whitened and bear the *nganzi* tattoo, a distinctive facial decoration once worn by Nkanu men and women. Occasionally a sculptor would deviate from the prescribed pattern. For instance, a European nun wearing a white robe, white kerchief, and black shoes (cat. 18) is uncharacteristically depicted with a white face as though the sculptor wanted to make it clear that missionaries transcend racial differences. The shape of the nose, the width of the lower jaw, certain coiffures, and the presence or absence of a mustache or beard also serve to indicate whether the individual portrayed is European or Congolese.

European and Congolese figures

Nkanu sculptors obviously represented Europeans as they saw them in their midst. Europeans, portrayed as tradesmen, regional administrators, and missionaries, are distinguished by distinctive details, especially in clothing. Sculptors usually portrayed a colonist wearing a colonial helmet, a shirt with an upright collar, a buttoned vest or jacket, pants, and shoes.

Depicting Europeans was a popular theme among *nkanda* artists. Clan histories told by older Nkanu frequently proclaim how their ancestors resisted the first European settlers, who were called *Bula Matari* (rock breakers). Nkanu proverbs, like the one recorded by Ryckmans (1957: 570–71), reflect the hostility the Nkanu felt toward colonial political and administrative structures: *Batukokele bakulu, bamfumu, bambuta ye baleke, ye atukondelekondele, Mundele* ("They have summoned us all: the chiefs, the elders, the young, and have shaken us. It is the European way"). Aversion toward Europeans is evident in the words that were uttered to ward off a visit from the regional administrator and tax collector. *Mundele (mu) simu, nganga (mu) simu* ("the white man [on] one bank of the river, the specialist [on the other] bank") meant each individual is master of his domain; these powers must be kept separate. European colonists were also mocked in those days. The Nkanu considered Europeans—and the neighboring Yaka—uncivilized, no

more than savages, and referred to them as *madiadia*, (those who eat anything) because they did not respect any food taboos or other ancestral rules.[5] Father Huveneers noted the threat Europeans presented (Popokabaka 1944:9):[6]

> The following song is often sung by the porters when they approach the village. For my sake, they have modified the text: *msondo* has been replaced with *bisaka*. For a long time, I did not understand the malice in this song: in fact, it announces that the white man will take their women!

> Solo: Go! Tear them!
> Chorus: Tear the vaginas!
> Solo: Go! We have slept with your mother!
> Chorus: Go! Tear the vaginas![7]

Congolese men or women are often depicted partially clothed or nude. Some sculptors "dressed" their figures with painted clothing and details, while others attached raffia skirts. Nkanu women are frequently depicted in traditional festive costume, wearing a skirt and bodice studded with beads. The artist usually paints the bodice above the breasts, so they are clearly visible to indicate whether the woman is of marriageable age, pregnant, or breastfeeding.

Congolese men are rarely depicted in a Western-style suit or uniform. Congolese wearing Western-style clothing and working for Europeans at the turn of the twentieth century were called *les blancs noirs* (black whites) and treated with disdain. Tradition prohibited a chief from dressing in Western fashion, that is, a shirt and pants.[8] There are examples of *nkanda* wall panels, however, that depict Congolese as uniformed soldiers of La Force Publique, the Congo Free State army organized in 1888 (cats. 6 & 7).

Whether depicting a Congolese or a European, the Nkanu sculptor usually had in mind a particular individual he wished to present. Nkanu informants commented on the interest in creating "portraits" and noted skilled sculptors were able, by focusing on a few striking characteristics and details such as clothing, to capture an individual's likeness. Those depicted were usually individuals everybody knew and publicly ridiculed. One such individual was a short, ugly man named Nkenena whom the *nkanda* sculptor had selected because everyone made fun of him. An Nkanu informant recalled a *kikaku* display depicting Mr. Vanbinnenbeeck, a regional administrator of Madimba, reclining in a litter. He had a reputation for being strict and merciless and was usually transported by bearers throughout the district in a litter.

Figural groups

Depictions of men and women together are not uncommon in *nkanda* wall panels. Whether the woman is portrayed with a Congolese or European man, she is usually positioned to the man's right (cats. 1 & 3). Depictions of interracial couples were

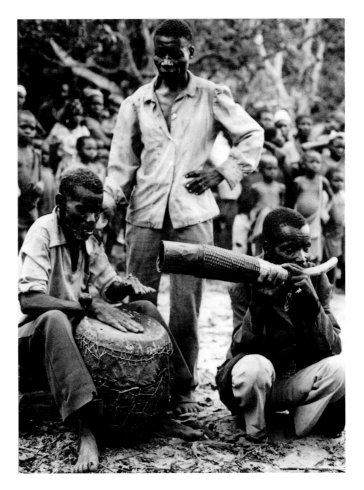

Fig. 13 Domingielo Lunsunsi, Nkoso Mpasi, and André Mpununu, members of the *masikulu* orchestra of Kimwanga, 1991

apparently a favorite topic among Nkanu sculptors and undoubtedly of great amusement to the community. A woman in such compositions is often represented as balanced, placing both hands at the same level on her abdomen or chest. This gesture suggests the woman is pregnant and "speaking with the child" in her womb. Full breasts, taut belly, and red skin (showing maturity) also indicate she is pregnant.[9] Sometimes, a woman is represented at the moment of childbirth. A wall panel illustrating childbirth (cat. 1) depicts a woman, hands on her abdomen, clenching her teeth as she bears the pain of labor. The child's head is already emerging from the womb. Examples of mothers with a child on their hips (cat. 17) or back represent maternity, fertility, and the pride of motherhood *(mabuta)*.

In the representation of a male and female couple, a European man is usually depicted clapping his hands. The crossed palms and slightly bent fingers create a loud dull sound. Among the Nkanu, clapping one's hands three times is customary when greeting a group of people or a respected individual, such as an elder, a parent-in-law, a chief, or an *nganga* (healer, diviner). The gesture is a sign of acceptance, be it a situation or a gift. Catalogue number one illustrates a regional administrator or missionary accepting an Nkanu woman's child as his own or agreeing to raise the child. A quotation from Van Wings' study

(1959: 218) seems to apply to this scene. "When the child is given its name, the *nganga* speaks: 'Then, he asks his assistants, *na usa konso, uzangula muana!* (Who will say *konso* and raise this child?)' The greeting *konso* is given by clapping one's hands."

Depictions of performing musicians are well suited for dynamic experiments with asymmetrical compositions to suggest movement (fig. 13). Albert Maesen (1969: fig. 8) notes that the search for dynamic representations was characteristic of some Nkanu sculpture. This is certainly the case with the well-known Nkanu drummer figure (cat. 19). Other figural representations, however, depict musicians in more conventional static or rigid poses (cat. 8).

Faces

While most Nkanu figural sculpture depicts the entire human body, there are examples of wall panels that depict a human face emerging from the painted background. An anthropomorphic head with bulging, often half-closed eyes, prominent nose, open mouth with filed teeth, and wearing the *n'ganzi* tattoo pattern and a "halo" surrounding its face represents the image of a Kisokolo mask. Representations of Kisokolo, a notorious womanizer, are often displayed next to wall panels depicting European men. A mask or panel depicting an anthropomorphic face with concave eyes and puffy cheeks represents the sightless Kakungu mask (cat. 12).

To advertise their skills and command of the visual language of initiation arts, Nkanu artists also carve small models of *nkanda* masks. These small masklike panels, which depict an anthropomorphic or zoomorphic face (cats. 12–15), are flat at the back and cannot be worn as masks. The panels were placed in the thatched roof of the *nkanda* house and were thought to have the power to stop rain[10] (Plancquaert 1930: 112). According to informants, they had a protective function and fulfilled the same role as the masks or head posts during the period when the carver had not yet completed these objects, which are necessary for the *nkanda* to proceed without difficulty.

The most important *nkanda* masks—Kakungu, Kisokolo, and Makemba—are represented in these small panels. Initiates and elders alike could commission an *nkanda* mask or head post by selecting the desired form from one of these panels. After *nkanda,* the sculptor would store the miniature panels until the next *nkanda.* If they were not saved, the panels would be destroyed along with other objects, when the enclosure was set on fire at the close of *nkanda.*

Animals

Carved representations of domesticated and wild animals in *nkanda* art teach initiates positive values of cooperation, friendship, mutual respect, and regard for the authority of the traditional chief and the ancestral spirits. Among the animals depicted are elephants, buffalo, antelope, goats, feline predators, including leopards, civets and genets, cats, dogs, guenon monkeys, snakes, chameleons, tortoises, and various birds.

Why particular species of animals were selected and what meanings the sculptors wished to convey have been discussed by several scholars. Coart and de Hauleville (1906: 150) see a link between animal fetishes and the belief in sorcerers who can take on animal shapes to carry out insidious plans. R. Wassing (1977: 88), on the other hand, suspects the panels represent totemic animals. Every Nkanu clan has a particular animal as its emblem, a mythical creature that served the family well in the past. The ancestors solemnly swore not to hunt the animal anymore or eat its meat.

According to Nkanu informants, however, the representations of animals on *nkanda* wall panels or in figural sculpture has nothing to do with sorcerers or totemic animals. Kiala Nzombo declared woodcarvers like to depict animals with frightful teeth and claws. According to him, the animals represent the traditional chief (*mfumu mpu*) and his supreme power over life and death. Like many predators, the chief always captures the transgressors of ancestral laws "in his claws." Informants noted traditional chiefs are sometimes ridiculed during *nkanda*—unacceptable outside the context of *nkanda* because chiefly power can potentially help or harm people).[11]

When two or more animals are depicted together, the message often concerns conflict and resolution. Animals that devour each other show a lack of mutual respect. The prey is often a hen, a small antelope, or an unidentifiable quadruped and symbolizes those who do not take the ancestral rules seriously. The late Professor De Graeve[12] asserted the subject represented a "devouring theme," which evoked the ritual killing of the boys at the start of the *nkanda.* Nkanu informant Domingiele Mvwaka explained that these portrayals warn initiates to respect one another and value their friendships.

Color

One of the most striking features of *nkanda* art is its extensive polychrome decoration, which the artists use to add non-sculpted details—clothing, hair, facial and body details and decoration—to wall panels, human and animal figures and masks. Nkanda artists incorporate a large number of distinctive surface designs or motifs on the two-dimensional background surfaces of the wall panels. These designs and their symbolism will be discussed below. It is important, however, to emphasize that the specific colors employed in the surface decoration is not arbitrary. The selection, combination, and juxtaposition of color is clearly intended to suggest additional meanings within the context of *nkanda.*

One caveat should be noted, however, in regard to the current shared understanding among *nkanda* elders about color and design symbolism. With the diminishing importance and frequency of the *nkanda* and the almost complete decline of the initiation ritual as an important context for ideographic writing, those well versed in the symbolic value of color and

these graphic elements have undoubtedly diminished. Some design elements have been reduced to decorative surface patterning, while others are still used, but in different ritual practices. Some Nkanu healers accept the loss of ritual knowledge and have commented that they no longer fully understand the significance of certain acts they may perform. They added that they are performing acts or making ritual gestures or signs "in accordance with the customs left to us by the ancestors."

Although artists employ a multicolored palette, including different earthen colors ranging from yellow, over pink and ochre to brown, the three dominant colors on initiation wall panels are black, white, and red.[13] The nuances and descriptions of Nkanu color are often reduced to one of the principal colors. Yellow, for example, is referred to as red, suggesting the color symbolism is restricted to the three dominant colors.

White *(mpemba)*, which symbolizes masculinity, knowledge, and wisdom, is, according to Nkanu informants, the color of the Supreme Spirit Nzambi and of the benevolent beings *(bakulu, bankita,* and *bisimbi)*. It is also the color of death because the bones of the dead turn white. Mpemba is the name for the ancestral spirit world. During *nkanda,* the initiates are like spirits in the Mpemba world: they, too, are on the threshold and are rubbed with kaolin to represent the liminal phase they are in. Decency, moral righteousness, and stability are also qualities embodied by the color white. White, as a symbol of light, purity, and innocence, contrasts with black.

Black is the color of darkness, impurity, and guilt. It is the color of extinguished charcoal and tobacco pipe residue, which are interpreted as symbols of guilt.[14] Blackness and darkness are associated with evil forces wandering through the night and are personified during the *nkanda* ritual. As *nkanda* draws to a close, the neophytes blacken themselves with charcoal and enter the village at dusk to steal hens and other food.

Red is the color of emotions and traits the Nkanu associate with women. Because of its ambiguity red is also connected with mental and physical instability and the transitional periods in one's life. Red also symbolizes modesty and maturity (Fu-Kiau 1969: 130), which is manifest when Nkanu women, especially pubescent girls, apply rouge made from *ndala menga* seeds to their cheeks. In the context of the *nkanda* ritual, red epitomizes the transition from childhood to adulthood. Jacobson-Widding (1979: 159) describes red as "a means of intensifying sexual desire" when the initiates rub their bodies with a mixture of red pigment and palm oil toward the conclusion of *nkanda.*

The combination of red and white conveys several meanings. By juxtaposing feminine qualities such as sensitivity and emotion (red) with masculine characteristics such as intelligence and insight (white), the Nkanu are calling for the preservation of the social order. Red and white, respectively, also link the forces of the earth with those of the ancestral world. Jacobson-Widding notes that the combination of red and black among the western Kongo stands for malevolent

forces. Black and white touches indicate opposing values: good is set against evil, light against darkness, strength against weakness, social order against chaos (1979: 303).[15]

Among the western Kongo, the combination of black, white, and red is linked to mythical clan ancestors, the establishers of current social and political laws (Jacobson-Widding 1979: 303–4). She believes that masks and sculptures produced by the western Kongo and painted in the three dominant colors embody ancestral spirits.[16]

The design elements assembled into decorative patterns embellishing *nkanda* art reveal much about the Nkanu world view. To those who can read their iconography, the designs or graphic elements are the equivalent of written documents.[17] Interestingly, *binuatu* and *bisono,* the words the Nkanu use for designs, have the same dual meaning: they refer to both designs and letters. *Binuatu* (sing. *kinuatu*) is derived from the verb *kunwata,* which Dereau (1957: 31) defines as writing, engraving, tattooing, inscribing. *Bisono* (sing. *(ki)sono)* is derived from the verb *kusona* and is defined as "drawing" (Butaye 1910: 246) and "to make a mark, to write" (Bentley 1887: 418–19).

If a design is like a letter, a pattern of designs can be read as a text. Thus, the artist who creates the objects employs an artistic language of shapes and colors that allow the artist to emphasize or expand the symbolic value of a representation. Consequently it is sometimes hard to discern a connection between the subject and its graphic language, such as the checkered pattern on the snake in catalogue number eight. There are examples of Nkanu artists directly translating the visual world into powerful sculptural statements, such as the Gabon viper with realistic patterning on its skin (cat. 10). The Nkanu also appear to adhere to the metonymic principle in which a single or repeated design evokes an animal and its metaphorical meaning. For example, the band of triangles on a viper's back may be used independently as a pattern to represent the reptile.

In order to grasp the deeper meaning behind these graphic elements, a short sketch of the Nkanu world view is necessary (fig. 14). The Supreme Spirit[18] Nzambi is said to have created three heavens. The first was his own home and that of

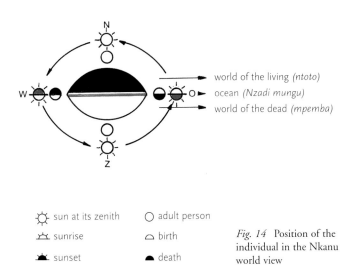

Fig. 14 Position of the individual in the Nkanu world view

world of the living *(ntoto)*
ocean *(Nzadi mungu)*
world of the dead *(mpemba)*

☼ sun at its zenith ○ adult person
⸬ sunrise ◠ birth
◖ sunset ● death

the celestial bodies; the second was known as Mpemba, a place for the souls of the dead who had lived a virtuous life on earth; and the third was earth *(ntoto)*. Mpemba (the hereafter) is the exact mirror image of the heaven of the living (earth). Nzambi created earth as a convex surface with a hard crust like a termite hill. It became home to people, sorcerers, and spirits. Nzambi also created the animals and plants that populate the earth to this day.

In the Nkanu world view, the earth is surrounded by water. The line between the first two heavens makes up the horizon, the coastline, and the boundary between life and death. Four pillars, connected by a spider web at the top (the sky), support the heavenly vault. In the beginning, this spider web ensured direct contact between Nzambi and humanity. This came to an end when the line broke.

Nzambi forged the heavenly bodies that circle the immobile earth. The sun and the moon were conceived as husband and wife; the stars, their children. The sun's adultery (some say an argument over) with the morning star led to the separation of sun and moon. Now they chase each other, taking turns appearing in the sky. The spots that can sometimes be seen on the moon's surface are proof of their domestic quarrel—the sun has stained the moon with mud.

Nkanda surface designs

It is clear, then, that both the color and the designs applied to the flat backgrounds of wall panels, figural sculptures, and masks are not simply decoration: they convey a range of meanings. The following designs are some of the more important that repeatedly appear on *nkanda* wall panels.

Cross

Among the Nkanu and Kongo-speaking peoples, the concept of the eternal voyage of the sun and the individual is symbolized by a cross (fig. 15).[19] This ideogram is also a crossroads. The intersection of roads is an important, magical place. Specific ritual phases take place here. Disease, misfortune, a dead sorcerer, or *nganga* buried at a crossroads or at an intersection of lines isolates the malicious forces. This isolation is called *kusa ku konda* (setting up a spider web) in which all evil forces will be caught in the web. The intersections also have purifying effects, restoring order to disrupted situations. A crossroads is a gateway to the first and second worlds whereby a centered vertical axis establishes contact with the forces of the underworld and the world above.

Fig. 16

The semantic content of the cross is thus fairly complex and comprehensive for the Nkanu. It is a static element (cross, crossroads) and yet a perpetual motion machine—the wheel of cyclical time, the consecutive appearance of celestial bodies, and the continuous change in an individual's lifetime.

A symbol in the shape of a St. Andrews cross sets up an artificial border *(kikaku)*. Roadblocks in the shape of crossed twigs warn the uninitiated that a ritual is taking place nearby and their presence is not wanted.

Two diagonal lines in a square (fig. 16), according to informants, are connected with the *masamba* fibers that the *nkanda* initiates wear crossed over their chests. They are symbolic of fertility and the sexual maturity of the wearer. They also have protective powers.

Spiral

The spiral (fig. 17) is connected with the cyclical passage of time and human life. Its meaning is apparent from *mvu*, the Nkanu word for this shape. Bentley (1887: 360–61) discloses the semantic wealth of this term: "*Mvu*: a season, year, time (season); old age, gray hairs; spiral, spiral screw, worm of a screw, screw propeller." *Nzioku-nzioku, zingu,* and *nzingu-nzingu* are also associated with this design. The latter two words are derived from *kuzinga,* which means to swaddle or to interweave. *Nzinga,* another derivative of this verb, is given as a proper name to a child born with the umbilical cord around its neck. It is generally believed that such a person will have a long life. The spiral, which informants linked to the coils of a large Achatina snail's shell, is thus symbolic of longevity.[20]

Elements of nature or culture (e.g., the twisted bracelet of the traditional chief[21]) that have a circular or spiraling shape are thought to possess exceptional magical powers. Because the spiral's basic shape repeats the creative motion of Nzambi or Mahungu,[22] an Achatina shell or spiraling antelope horn is used as a container for potions. An *nganga* who seeks out a whirlpool to dip his paraphernalia into is given supernatural power, which can be found in the deepest of waters. The uninterrupted motion that produces energy is also summoned by the healer as he circles a patient with entangled lianas hoping to speed up his or her recovery.

Fig. 15

Fig. 17

Fig. 18

A complex spiral design (fig. 18) consisting of a rectangle with a spiral at its four corners represents a seated chief or his seat or headrest. According to some, the spirals are the bracelets of a chief who guards the well being and fertility of the members of his family day (seat) and night (headrest). Others believe clockwise spirals represent the chief's male descendants and counterclockwise spirals, his female descendants.

Circle

The symbolic value of the concentric circle (fig. 19) is related to that of the spiral as the terminology shows: *kizunguluku* is translated as the winding thing; synonyms *(ki)nziunga* and *nzunga,* as circle or circumference. Different Nkanu sources connected *ntangu* (sun, time, point in time) with the design. Material objects having a circle as their basic shape—the chief's bracelet and thigh ring, a pot ring, the royal court—contain special power. The same power resides in a whirlwind or whirlpool. An empty circle with a halo—a solar symbol—is a recurring design (fig. 20) in initiation panels. Some sources associate the circle with a spider web; others with the notion of *kati-kati* or center.

Fig. 19

Fig. 20

Lobes

The moon appears in the lobes or semicircles inside a ring or rectangle (fig. 21). *Ngonda,* the Nkanu word for moon, also means point in time, month, and season. Because its appearance changes cyclically, the moon is an excellent calendar for the planning of certain activities. Specific social groups—women in general,[23] initiates participating in rituals, and hunters—know how to read the moon's positions. Important business, whether it has to do with profit or sexual relations and fertility, is handled only under a waxing moon. Dark purposes, such as sorcery, are best served under a waning moon. Each new moon concludes a period and is believed to have a positive effect on certain situations or conditions.

Fig. 21

Arc

Informants interpreted a simple arc or curve (fig. 22) as a rainbow or mountain. The compound design of juxtaposed semicircles (fig. 23) visualizes the universal attraction between man (horizontal line) and woman (arc), earth (horizontal) and heaven (arc), procreative (horizontal) and receptive genitals (arc). Several sources mentioned the verb *kubindasa,* which means combining or interweaving, when they saw these compositions. Interweaving is a metaphor for marriage or a sexual relationship. A series of semicircles or arcs represents couples. Juxtaposed half circles filled with dots (fig. 24) symbolize couples and their offspring. A series of arcs, filled alternately with dots and slanted lines (fig. 25), evokes a disrupted balance.

Fig. 22

Fig. 23

Fig. 24

Fig. 25

Square or rectangle

A simple square (fig. 26) is a three-dimensional image to the Nkanu: it must be seen from different perspectives (from the top and the side). The four corners represent the points on earth where the four pillars supporting the universe are planted. The bottom horizontal line is the earth's surface, the top one is the sky. The right vertical is associated with the sun and the east; the left, with the moon and the west.

A quartered rectangle (fig. 27) with two colored opposite triangles represents contact between two worlds: men and the supernatural powers, patrilineal and matrilineal clans, and man and woman. According to our sources, alternating black and white triangles refer to opposing forces.

Fig. 26

Fig. 27

Fig. 28

Fig. 29

Fig. 30

Fig. 32

Nkanu informants associated a series of linked diamonds or a seesaw design (fig. 32) with the Gabon viper or the pattern on its back.

Movements during sexual intercourse, sexual arousal, and the impregnation of a woman (with dots as sperm) are represented by subdivided rectangles (fig. 28). The male genitals appear in the top triangle, the female genitals in the lower triangle, and the labia in the left and right triangles. A chevron design within a rectangle (fig. 29) represents an open vagina. The small triangle—placed at the bottom of the first design and to the right of the second—represents the anus. The dots delineate the skin and the pubic hair. The composition of two hatched and one crosshatched triangles (fig. 30) also evokes sexual intercourse.

Diamond

A diamond (fig. 31) is drawn in the sand by someone calling on higher powers for help. It automatically creates a ritual space and enables the supplicant to establish contact with forces from the different worlds. At the same time, it isolates the person or thing brought within the design, thereby protecting them from sorcerers.

Serrated lines or scales

Serrated lines or scales (fig. 33), filling up a surface or the body of a feline predator or tortoise are found on some initiation wall panels. The symbol is also identified as the scales of a pangolin. Like the leopard, the pangolin is associated with traditional leadership. Informants shown the pattern depicted in figure 34, mentioned the proverb *Mfumu ngo makedi, bantu, yuna ukwe twaadi niku mu mwe kadi mbongo bantu* (King leopard has a spotted skin; for the people, he who walks should have subjects).

Fig. 33

Fig. 31

Fig. 34

Fig. 35

Triangle

The three points that delineate a triangle (tattoo design) and the closed geometric shape (fig. 35) summon images of termite hills. The triangle symbolizes three mushroom-shaped termite hills *(makuku)* or rocks supporting a pot over a fire. This image is strikingly expressed in the proverb *Makuku matatu mabidilanga nzungu, mole nlama. Mwana kiyaya, mwana kitata, mwana kinkaka* (Three clumps of earth give solid support to the pot; two create problems. [One is the] child of a matrilineal clan, of a patrilineal family, and of the grandfather on the mother's side). The base of the triangle represents the matrilineal clan; the right side, the patrilineal family; and the left side, the maternal grandfather. These are the three pillars of social life. A person can always turn to one of these families, but he or she also has obligations toward them.

When the top points up, the geometric motif also symbolizes the first human being or the male sex organ; if reversed, it stands for the female sex. Some Nkanu sources alluded to the great symbolic value of the number three and its multiples in Kongo philosophy.

Phytomorphous designs

Nearly all the Nkanu sources identified symbols with four or more leaves (fig. 36) as phytomorphous designs. They associated the designs with the words *mvuma* (flower), *paka-paka* (calyx), *lukaya* (leaf), and *lukaya lu nsaki* (manioc leaf). These are stylized flowers of the manioc plant, which holds great symbolic value for the Nkanu: the leaf symbolizes the female principle, while the root is a metaphor for the male organ.

Trefoiled flowers (fig. 37) represent the open fruit of the *n'titi* or *mbatakala* plant, in which the male organ, testicles, and anus are recognized. During the circumcision ritual the leaf of the *n'titi* is used to bandage the circumcised penis. The white juice secreted by the plant is compared to sperm. The initiates are also made to chew the bitter roots of the *n'titi* to enhance their procreative powers.

Fig. 36

Fig. 37

Notes

1 The objects made by the Nkanu for healing practices and divination sessions are not discussed in literature. They are anthropomorphous statues of limited size (20 to 60 cm), usually very schematically designed, covered with magical materials and a monochrome crust of sacrificial patina. They represent men and women in a stiff posture, knees slightly bent and hands folded on their chest.

2 The literature repeatedly characterizes Nkanu wood sculpture as heavily influenced by that of their neighbors, the Yaka.

3 When this wood is not available, they will also use *ngoma-ngoma* or *nsenga* wood, which is not as hard.

4 Objects made by the Baule of Côte d'Ivoire or the Fang of Gabon, among others, enjoy this status.

5 This is confirmed by Van Wing (1959: 225(14)). He writes about a name used during the puberty rituals that was explained to him as follows: *Nsungu Mputu, ka basungula kima ko, nlongo wu dia.* ("The white European, he qualifies nothing, he eats forbidden things; he looks at nothing, does not call anything by its proper name, and, whether it is a forbidden thing or not, he eats it anyway. *Nsungu Mputu* is an ironic name for whites: the Bakongo use this name to talk about white people in their presence, to make sure they do not understand what they are saying.")

6 The Jesuit Huveneers collected *nkanda* song lyrics from the Kwango and other regions (Popokabaka, 01.12.1944).

7 The author translates *msondo* as vagina. Clitoris would be more correct.

8 Some of the songs mocking the black *évolués* were recorded by Struyf (1911: 100).

9 The balanced placement of the hands in front of the body can also represent an attitude of prayer or supplication.

10 This is a power normally associated with Kakungu.

11 A chief is considered both a healer *(nganga)* and a sorcerer *(ndoki)*.

12 Personal conversation in June 1989.

13 The pigments are of mineral or vegetal origin. Different layers in certain riverbeds offer a variety of pigments that produce a yellowish pink color. The gathered clumps of earth are divided into small pieces and dried on *kivuyu* leaves, a process called *kuyanika mabunga*. The reddish-brown *ndimba* is obtained by burning clumps of grayish-black *nkala tuma* earth in an open fire. The white color *mpemba* can also be gathered in certain rivers (in the shape of kaolin, for example in the Fwa-Kikumbi lake near Kingemba-Kinga). Charred manioc roots produce a black dye. An olive green color is made by mixing broth from maniock roots with river clay *(tuma)*.

 The pigment is pulverized in a mortar and then mixed with latex (*ngodokulu* juice) and a dash of palm wine. The wine homogenizes the pigment, prevents the binding agent from becoming elastic, and gives the color a glossy finish after drying. The sculptor *(nganga luvumbu)* first applies a black primer to the base wood. After painting the designs, each decorative element is outlined in white.

14 A diviner *(nganga ngombo)* hands one of these materials to each party after divination has determined who the guilty party is. The latter gets the black charcoal, while the innocent get the white ashes or *n'toto*.

15 These antithetical forces are called *mamvutu-mvutu, buzengi,* and *ngolu zi suasana* by the Nkanu.

16 Nkanu informants connected masks decorated with black/gray, white, and red/orange pigments with Kakungu.

17 See the discussion in Mveng (1980: 46, 49).

18 I prefer to use the phrase Supreme Spirit rather than Supreme Being or God, because it seems mistaken to me to say—as many do—that the peoples of the Kongo originally had a monotheistic religion. After contact with Western culture and the Christianization of the area, Nzambi (a) mpungu was equated with the Christian God. Presumably, it was not until after this time that the local religion came to be considered monotheistic. In addition, research indicated that, among the Nkanu, Nzambi took the place of a bisexual primal force called (Ma)Hungu or Ngu.

19 Thompson and Cornet (1981: 120) attached the following meaning to the crosses they found on objects from the western Congo: "The Bakongo believe that humanity has no ending; it completes a circle, just as the sun does by rising and setting. The sun is therefore symbolic of the circle of life and death is a gate on this path of change (rebirth) (Fu-Kiau)." They summarize its symbolic significance as "the four moments of the sun," also the title of their book.

20 MacGaffey (1993: 67) notes for the western Kongo, the shell is symbolic of a long life *(zinga)*. "Shells, as the perdurable houses of creatures that were once alive, are almost synonymous with 'long life' in traditional Kongo thought. The spiral form itself, *zinga*, also means 'to live a long time,' and the ancestors thought that the child in the womb was like a snail in its shell."

21 One of the traditional chief's bracelets is called *nlunga kwenda ye kwisa* (ring of coming and going). It lends the chiefs their authority and also has protective powers.

22 Mahungu, a primal creature "more woman than man," is said to have walked around a tree. As a result, "it" split into a man and a woman, the first human couple. The idea behind repeating this rotating motion during healing rituals is to return to the original bisexual nature of the patient, in order to "recreate" him or her (free of illness).

23 A woman calculates her menstruation cycle or pregnancy by the manifestations of the moon. In fact, the word *ngonda* also means menstruation. When a woman is pregnant, the Nkanu say *"ku nima ngonda kena"* (she is behind the moon.)

Catalogue

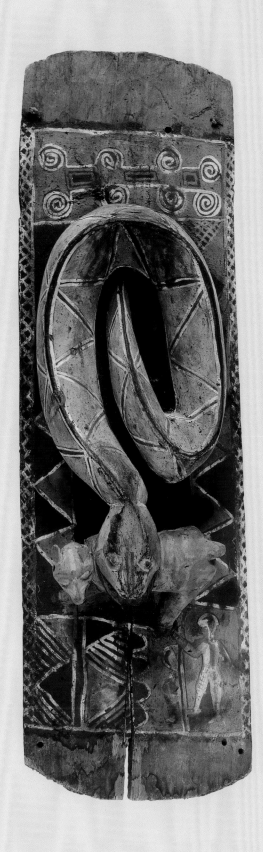

Initiation wall panels and freestanding sculpture

The most distinctive forms of Nkanu initiation-related arts are the complex of decorated wall panels and sculpture associated with the *kikaku* enclosures. The *kikaku* is a roofed enclosure with three walls constructed near the conclusion of *nkanda* between the initiation site and the village at the intersection of two paths. The initiates gather the necessary materials (branches, lianas, and straw) and build an open construction following the elders' directions. The size of the building is partly determined by the number of decorative wall panels the sculptor has made. The *kikaku* has been described as an *nzo biteke* ("house [of] statues"), which refers to the colorful panels on the walls and the freestanding figures placed either on the floor or a platform in front of the panels.[1]

A ritual specialist installs powerful defenses to protect the *kikaku* against malevolent forces. No one is allowed, under penalty of death, to touch the objects inside the *kikaku*. When the construction is completed, the *kikaku* is shielded from view by a palm leaf screen, which is removed on the eve of the dances by the ritual specialist or an elder wearing the Nkoso mask.

The main purpose of *nkanda* is to safeguard the procreative powers of the male adolescents. It is hardly surprising that the thematic content of the wall panels and the figurative sculpture are concerned with human fertility. This is immediately obvious in figurative sculpture that depicts accentuated genitals, copulation scenes, pregnant and childbearing women, and mother-and-child images. More often, however, the theme is hidden in metaphors that are not immediately clear to the uninitiated.

According to informants, sexual intercourse is staged during initiation by using three-dimensional sculptures of a naked man and woman. Confronting the initiates with these kinds of images tests their virility and makes them aware of their responsibility to ensure the continued existence of the community and complete the cycle of life through their procreative powers.

Some images on the initiation wall panels refer to the final stage of *nkanda*. Although scenes depicting the initiates in their dance costumes and musicians playing drums speak for themselves,[2] other scenes contain hidden allusions to this final celebratory stage. It is believed the boys have a "liminal" existence within the initiation enclosure and are "reborn" at the end of the seclusion period. Depictions of death are found in representations of animals being devoured and appear to be depicted in the images of Europeans and Africans with white faces. Near the conclusion of the rite, the initiates rub themselves with a red pigment, the color of life, in front of the *kikaku*. The receptacle for the pigment is a small hole in the ground or a recess, such as the center of the coiled snake in the floor sculpture (cat. 11).

This crucial phase of ritual rebirth is represented by images of pregnant women and women giving birth. At the conclusion of the rite, the initiates are accepted as full, adult members of the community. This is evidenced by the depictions of human figures on the initiation wall panels and the figurative sculptures that are usually depicted as young adults in the prime of life. This is further reinforced by the depiction of babies in maternity images wearing *n'ganzi* tattoo patterns that were worn by adult men and women in Nkanu society (cats. 1 & 17).

Despite the crucial importance of the closing event and the goal of *nkanda* to ensure the procreative powers of the initiates, ridiculing the fundamental values of human (and animal) sexuality is accepted within *nkanda*. What must be treated with the utmost respect in daily life can be mocked in the context of *nkanda*. The initiates, for example, are forced to insult their mothers, particularly their sex. The expression *ngu'aku* ("your mother" and "your mother's sex") is considered a grave insult under normal circumstances. During *nkanda* ridiculing traditional leadership is also fair game. While the community chief commands awe and respect in daily life, within *nkanda* he may be derided and ridiculed. The European male, represented as a

missionary or a regional administrator, is also often mocked. Critical remarks and insults within the context of initiation have a cleansing effect: they resolve social tensions.

The wall panels are created and displayed to instruct the initiates during the course of *nkanda.* The esoteric knowledge that is to be passed on to the new generation of adults is encoded in the initiation wall panels (see fig. 12). Daniel Biebuyck describes Nkanu wall panels as "richly adorned with symbolic scripts, [that] serve as a visual aid" (1985: 199). Lema Gwete concurs, stating that "these objects with their various geometrical designs may very well have served as memory aids" (1993: 46). My own research suggests that the initiation panels have mnemonic value insofar as they are material aids to the *nkanda* specialists. As soon as the *kikaku* is constructed during the *kuyola Nkoso* phase, preparations are made to close the ritual with a celebration.[3] The sculpture and wall panels displayed within the *kikaku* present more or less the same iconographic message, which would explain the repetition of images. They offer the *banganga* the opportunity to apply their "sacred" knowledge repeatedly and thereby preserve it for posterity.[4] I suspect, then, on the basis of the information I was able to obtain, these are not so much didactic materials as conveyors of information in which the course material for the initiates is summarized. As the initiates look at the images in the *kikaku,* they receive no further explanation of the images and are expected to observe the proceedings in complete silence. According to informants, the initiates understand the meanings behind the sculptures because they represent events that have occurred during *nkanda.*

The combination of wall panels, surface decoration, and figural sculpture functions as a visual and symbolic language that can be read and interpreted by those educated within *nkanda.* These images speak of rebirth,

emotional and sexual maturity, death and the spirit world. In addition, the life cycle of the individual, according to Nkanu philosophy, is linked to the constant rotation of the celestial bodies and to large-scale developments in the universe. The most important cosmic elements—such as sun, moon, rainbow, and stars—can be found in the decorated background of the wall panels. The initiates are confronted with these images at the conclusion of *nkanda* and the start of a new phase in their lives. Renaat Devisch describes the *nkita (khita)* fertility ritual among the Yaka as a "cosmogenetic drama," leading to the ritual rebirth of those present (1993: 179).[5] Decorated wall panels within the context of *nkanda* have a similar intent. In other words, a creative force emanates from the carving and painting of these panels: the application of cosmic symbols suggests or illustrates the cyclical wheel of life and the universe in motion.

The display of the decorated wall panels and sculpture within the *kikaku* puts everyone on notice. To passersby the *kikaku* proclaims the *nkanda* is nearing its conclusion and warns antisocial individuals (sorcerers or *bandoki*) not to attempt anything during this crucial period.[6] The entire community is responsible for *nkanda's* outcome.

The sculpture and wall panels thus serve as a kind of symbolic beacon and gateway to adulthood, hence the name *kikaku. Kikaku* can be translated as "barrier" and also refers to any warning or stop sign directed toward the uninitiated. This is why the *kikaku* is built at a crossroads. The actual purpose of these panels, figures, and masks is to assure the boys pass from adolescence into adulthood smoothly. The final phase of the ritual is of the utmost importance—it concerns the welfare of a new generation of adults. Only after the *kikaku* has performed its ritual function are passersby allowed to see it. Then it becomes a general source of amusement as people are recognized in the images and laughter fills the community.

1 *Wall panels*

Nkanu peoples, Democratic Republic of the Congo
Wood, fiber, pigment
89.5 × 68.3 × 13 cm (35 ¼ × 26 ⅞ × 5 ⅛ in.)
Collected by A. Henrion before 1940
Africa Museum, Tervuren, RG44.430 (acquired in 1946)

On the left, a Congolese woman sits, her legs spread
and knees bent. She clenches her teeth as she bears
the pain of labor, which the sculptor expressed by
placing her hands on her abdomen. The baby's head
emerges from the womb. Sculptors from western
Kongo and Yaka communities depict birth in similar
ways. Bourgeois, for instance, describes a figure
representing a woman in labor on a Yaka mask
headdress (1985: 69). The redness of her skin
indicates her maturity. Her heavy breasts are visible
below the bodice depicted by the crosshatching on
the collarbone and upper arms. The pudenda and
clitoris are accentuated. The baby's face is white, like
its mother's, and bears an *n'ganzi* tattoo design.

On the right, a European man, dressed in a
white suit, a colonial helmet, and black shoes, claps
his hands—a gesture of greeting or acceptance. In
this case, the man acknowledges his fatherhood and
agrees to raise the child. Panels showing a Congolese
woman and a European man are often placed next
to each other, with the woman usually to the man's
right. Both figures are depicted with half-closed eyes,
which informants describe as a "lustful look." The
woman's red eyeballs refer to the proverb "red eyes
wide open, ears closed"; that is, the woman would
not listen to other's advice and must now bear the
consequences of her behavior.

Sexual references fill the background, which
is primarily composed of triangles. Behind the
man's left shoulder is a field of lobes filled with
dots (symbolic of the male sex), while a square or
rectangle representing a tortoise shell or the female
sex after copulation appears next to the woman.[7] The
parallel lines filled with dots between the figures' legs
may, according to Nkanu informants, represent the
contact between different worlds, marriage, and a
healthy offspring. The repeated hourglass-like design
on the top crossbar represents positions of the moon
or the female genitals with the vagina and labia
(lobes). Dots inside the lobes delineate pubic hair or
menstrual blood (center).

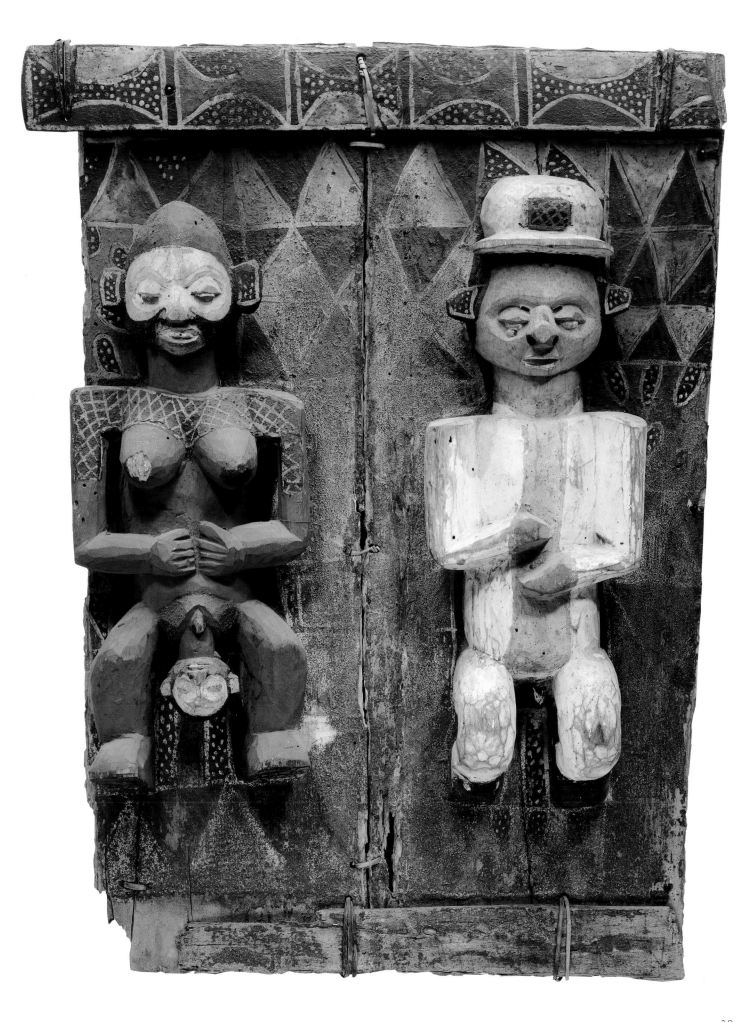

2 *Wall panels*

Nkanu peoples, Democratic Republic of the Congo
Wood, pigment
112.5 × 124.1 × 14 cm (44 ⁵⁄₁₆ × 48 ⅞ × 5 ½ in.)
Africa Museum, Tervuren, RG26.317 8/1–RG26.317 8/8 (acquired
in 1922)

These wall panels depict an Nkanu couple carved in high relief. The woman stands to the man's right. Their faces are painted with kaolin and their bodies are rubbed with red pigment. The man, possibly an initiate, has white arms and hands. The woman's gesture of placing her hands on her belly suggests that she is pregnant. The posture is known as *kugogisa (ye) mwana* or *kuwosa (ye) mwana* ("speaking [with] the child"). The man's attitude appears threatening. He is depicted with knees bent and pelvis tilted. His large, circumcised penis is hidden by a raffia skirt. This position is reminiscent of an initiate preparing to be circumcised. During his dance performance, Mbala, the titled initiate, adopts the same inviting pose to arouse the sexual desires of the women watching. Huveneers (1944: 19) clearly notes that the sexually charged dance movements of Mbala and accompanying songs provoke a response from the women in the audience:

> While talking, Mbala has lifted his loincloth and, revealing his genitals, he takes his penis in his other hand and shows it to the women: it is his gift! As a rule, the women will have brought their ([food basket]), which they hold out to receive this precious gift: we accept it, they say. If they have not brought their basket, they hold out their skirt, the way a cook holds out his apron to put food in it. Usually, Mbala does not show his own penis; a tapered cylinder made of very light wood (20 × 5 cm) hangs from his belt.

Another panel in this grouping depicts a bird flying. With its dark feathers, curved beak, stretched reddish brown neck, and dark feet, it may represent a purple heron—a bird said to lead a flock of black storks *(nkumbi-nkumbi)*. During *nkanda* initiates are often referred to as black storks. Not only do the initiates and storks have similar names—*bikumbi* and *nkumbi-nkumbi*—the initiates darken their bodies (recalling the stork's dark feathers) and imitate the bird's behavior at certain stages of the rite. There are

also striking parallels in Nkanu behavior. The "purple heron" (*nkanda* leader) leads his flock of "storks" (circumcised boys) outside the initiation enclosure to wash in the river or to farm, and then they return to the compound, in the same way that birds flock together when feeding or nesting. Just as the purple heron serves as a guide in flight, so does the leader who wears the Nkoso mask: he "shows the river." The parallels between the migratory birds and *nkanda* continue. The feathers of the *nkumbi-nkumbi* are used in the headdress of the Nkoso mask. Birds crossing to the other side of the ocean to winter suggests crossing the boundary between the worlds of the living and the dead. It also symbolizes the initiates' death and rebirth at the conclusion of *nkanda*. Finally, the return of the *nkumbi-nkumbi* birds and the start of the initiation ritual coincide at the beginning of the dry season.

The background designs reinforce the symbolic power of birds within the context of the *nkanda*. The concentric circles painted on the back of the bird represent the sun. The bird "flies" across three bands with a linked diamond pattern, which the Nkanu associate with the Gabon viper. Perhaps the sculptor intended to represent the earth (snake), the sky (sun), and the water or water bird in this composition. The semicircles enclosed in squares may represent the positions of the moon. The dots may be the stars or descendants. Triangles, spread across the panel touching each other at the top or base, represent the male and female sex or sexual intercourse.

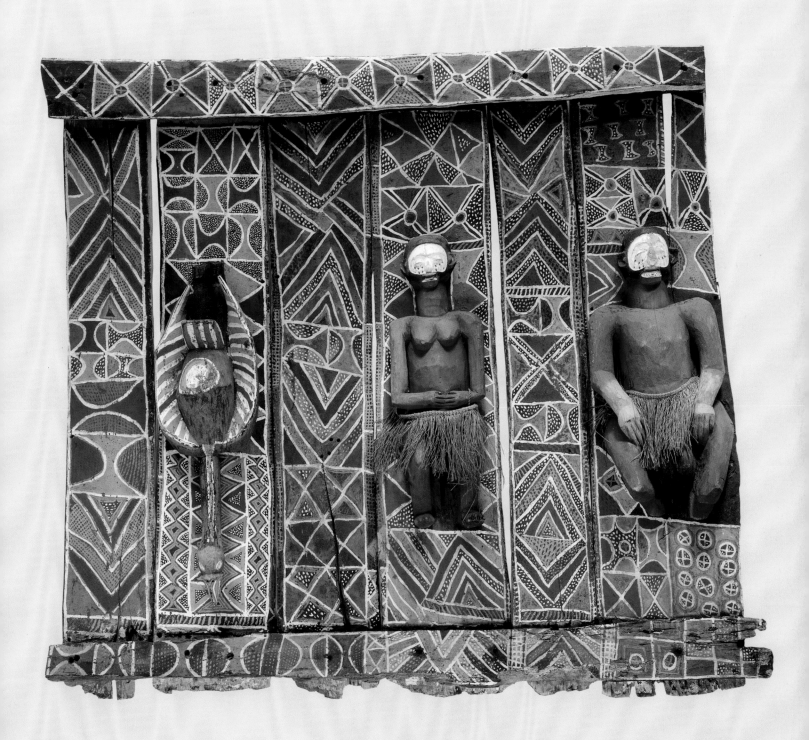

3　*Wall panel*

Nkanu peoples, Democratic Republic of the Congo
Early 20th century
Wood, pigment
99.2 × 33.5 × 14.9 cm (39 $\frac{1}{16}$ × 13 $\frac{3}{16}$ × 5 $\frac{7}{8}$ in.)
Collection of the Jesuit Fathers, Heverlee, on permanent loan to the Africa
Museum, Tervuren, 1340

The beautifully dressed figure in festive attire stands with her hands on her hips, adopting a provocative dance pose that is intended to arouse the male libido. The posture conveys a woman's pride, vitality, and sexual maturity. Women apply a mixture of palm oil and red pigment to their skin. In the past, elaborate beaded decoration was worn to emphasize a woman's status and that of her husband.[8] She would also adorn herself with brass rings and tie strings of blue and black beads under her buttocks to prepare for a dance.

According to an informant, this figure portrays a young woman who has been promised in marriage, as indicated by the beaded bodice she is wearing. In preparation for a wedding, the groom must turn to his maternal uncle who ensures that the bride was chosen from a non-related clan before consenting to the union. The young man then offers his future father-in-law two containers of palm wine and strings of beads (usually twelve). The mother of the bride-to-be ties the beads around her daughter's hips, indicating the young woman is spoken for, or as the Nkanu say, "the fence has been closed" *(kanga lupangu).*

The background is decorated with triangles, diamonds, four-leafed flowers, and concentric circles. Triangles filled with dots represent human beings, their offspring, or genitals with pubic hair; triangles with hatching, ancestral settlements *(mavwoka)*; linked triangles, the population of the region; and triangles with crosshatching, population growth or density. Linked diamonds symbolize the contact between two worlds. Some diamonds are filled with dots, which denote children. Four-leafed flowers designate the female sex, and small concentric circles symbolize the sun (male principle) or stars (eyes of the ancestors).

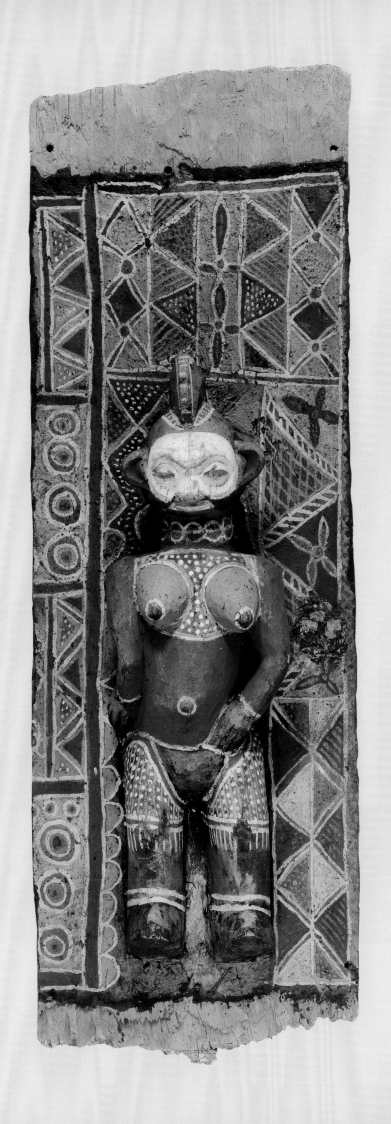

4 *Wall panel*

Nkanu peoples, Democratic Republic of the Congo
Early 20th century
Wood, fiber, hair, pigment
95.4 × 42.8 × 22.8 cm (37 ⁷⁄₁₆ × 16 ⅞ × 9 in.)
Collection of the Jesuit Fathers, Heverlee, on permanent loan to the Africa
Museum, Tervuren, 1346

Probably carved by the same sculptor as a companion
piece to the female figure (cat. 3), this carving depicts
a European man with light yellow skin, a mustache
made from tufts of animal hair, and Western-style
clothing. He is squatting on a black surface clapping
his hands, an indication that he is greeting someone
or accepting a situation.

Triangles, circles, and lobes decorate the
background. The lobes filled with dots refer to the
male regime of the palm tree and, thus, the male
principle. Triangles filled with dots represent human
beings, their offspring, or genitals with pubic hair.
Crosshatched triangles represent the homes of the
ancestors *(mavwoka)*; similar triangles with dots
between the lines symbolize hearth fires in the
villages. To some informants, circles filled with lobes
represent the moon; to others, they represent a magic
cross *(nkangi kiditu)* to capture the devil *(kiditu)*.

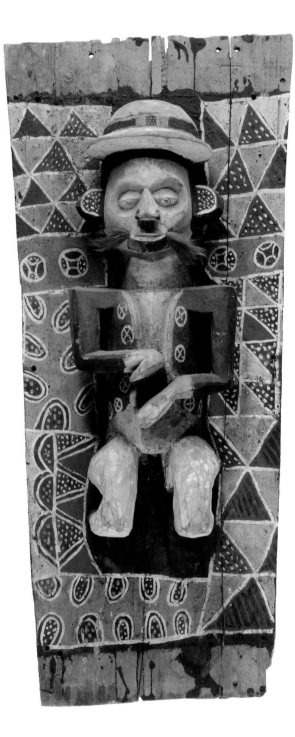

5 *Wall panel*

Nkanu peoples, Democratic Republic of the Congo
Wood, pigment
104.9 × 31.5 × 15 cm (41 ⁵⁄₁₆ × 12 ³⁄₈ × 5 in.)
Collection of the Broeders van Lourdes, Oostakker, Belgium
Not on exhibit

This panel portrays a European male holding a glass bottle. For the Nkanu, receptacles such as bottles, pitchers, and gourd containers are metaphors for the female womb. The body of the bottle represents the uterus, and the neck and spout, the vagina. An Nkanu proverb further illustrates the analogy: "One does not add palm wine to a full gourd." That is, you can have too much of a good thing. This proverb teaches initiates it is not wise to have sexual intercourse with one's wife late in her pregnancy.

Nkanu informants interpreted the man's gesture as *kusimba nlangi/ntutu,* (holding a bottle) or *kubita nlangi* (clutching the bottle), which is related to the Nkanu custom of offering a bottle of palm wine after consummating a marriage. The groom's family offers the bride's family a bottle of palm wine with a stopper (a full bottle) after the girl's virginity has been ascertained. If she is not a virgin, the bride's family receives a bottle without a stopper (a half bottle), a public sign of disgrace. The couple is forced to confess the names of those with whom they have had premarital relations. If they refuse, they risk cursing their children with chronic diarrhea.

The man depicted on the panel is clearly a missionary as delineated by the large cross in the middle of his colonial helmet. In this representation the sculptor is mocking the celibate clergyman by depicting him with eyes half closed, an expression that is interpreted as a lustful look. The clergyman is holding a closed bottle; that is, a bottle with a stopper which represents virginity. He wants to have intercourse with "her." Upon further analysis of two details in the panel, it appears the artist wanted to disclose the immorality of this scene: the man, wearing a frown, looks very dejected and the dog at the bottom of the panel is looking away from the viewer. The sculptor is emphasizing the reprehensible nature of the situation—even the dog, an animal with no sense of shame is showing its disapproval. The semicircles enclosed in triangles placed on each side of the clergyman's knees represent the "child in the womb."

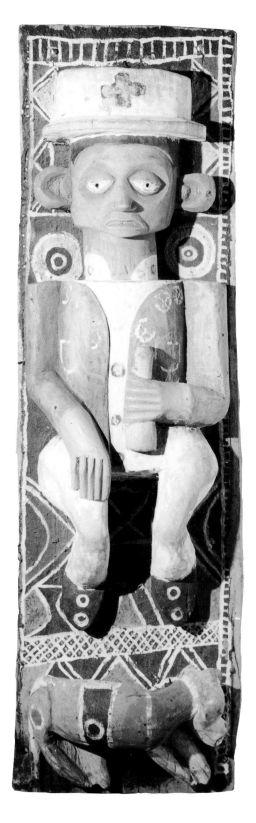

6 *Wall panels*

Nkanu peoples, Democratic Republic of the Congo
Wood, pigment
Soldier (RG46.17): 89.8 × 23.8 × 12.7 cm (35 ⅜ × 9 ⅜ × 5 in.)
European (RG46.16): 87.1 × 27.8 × 14.7 cm (34 ⁵⁄₁₆ × 10 ¹⁵⁄₁₆ × 5 ¹³⁄₁₆ in.)
Collected by Brother Ch. Gérard
Africa Museum, Tervuren, RG46.17 & RG46.16 (acquired in 1911)

The central panel of this figural grouping has been created to suggest the possible orientation and surface decoration of the original composition. The panels depict a uniformed soldier presenting arms and a European man clapping his hands. The hand gesture and its meaning of greeting or acceptance of a situation suggest that another now-missing panel might have depicted an Nkanu woman.

Sexual imagery dominates the background decoration. The open trilobate seed pods symbolize the male sex. A *nlolo* branch is depicted beneath the soldier. The foreskin of a circumcised boy is buried near the root of a *nlolo* plant. The word *nlolo* refers to forgiveness: it "lends forgiveness for the spilled blood" and reconciles the ancestors with what has happened. The *nlolo* plant is also said to survive bush fires and sprout quickly afterwards—indicative of the initiates' rebirth. The initiates also blacken their bodies with charred *nlolo* bark to indicate, as informant Emile Mbandu Konda revealed, they are unclean; the leaves of the plant are used as toilet paper.

The cross-shaped design above each character symbolizes the four stages of life and the daily rotation of the sun. The scaly pattern to the left of the man refers to a spotted feline. Note the man's shoes are patterned with the same design: perhaps the artist intended to portray the man's position of authority.

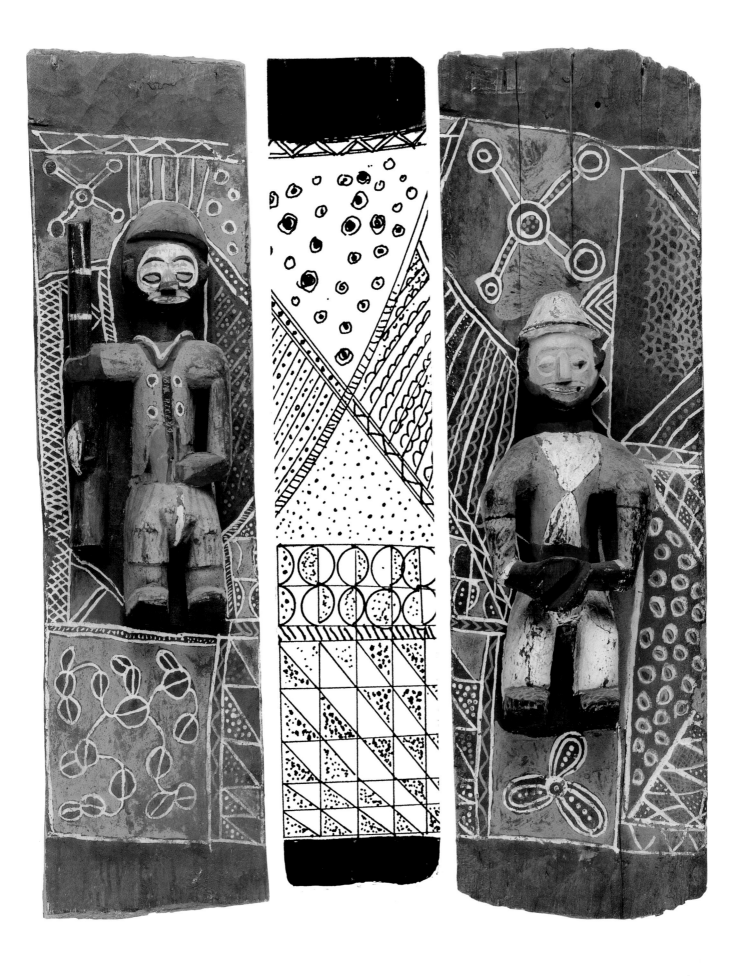

7 *Wall panels*

Nkanu peoples, Democratic Republic of the Congo
Early 20th century
Wood, pigment
84.8 × 132 × 18.5 cm (33 ⅜ × 51 ¹⁵/₁₆ × 7 ⁵/₁₆ in.)
National Museum of African Art, Smithsonian Institution, museum purchase, 99-2-1

These wall panels are full of references to power
and authority. Three panels contain human figures
in relief. The central figure, dressed in a white suit
and wearing a colonial helmet and boots, probably
represents a European regional administrator. The
two individuals flanking him—Congolese soldiers
of La Force Publique—are presenting arms.
Their uniforms consist of red berets, short vests,
and trousers. The soldier on the right wears an
ammunition belt around his waist; the other soldier
adopts an unsteady stance by standing on his left leg
and resting his right foot against his lower left leg.
Could this be an obligatory military posture? It is
more reminiscent of the position circumcised boys
assume at the new moon. As the cock crows on one
leg to greet the sun, so the initiates must find their
balance standing on one leg. The Yaka call this pose
kataku, which refers to the male's virile, impregnating
erection (Devisch 1984: 40, 63–64, 221).

The two panels separating the three figures are
embellished with three linked diamonds filled with
dots. This represents the female sex after intercourse.
The four-leafed designs, which represent the female
genitals with two pairs of labia, further add to the
sexual symbolism of the wall panels.

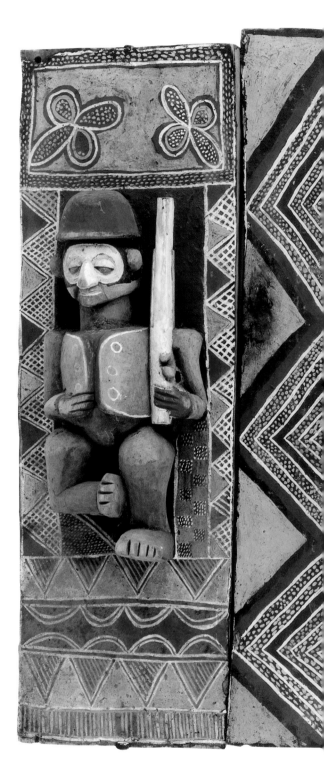

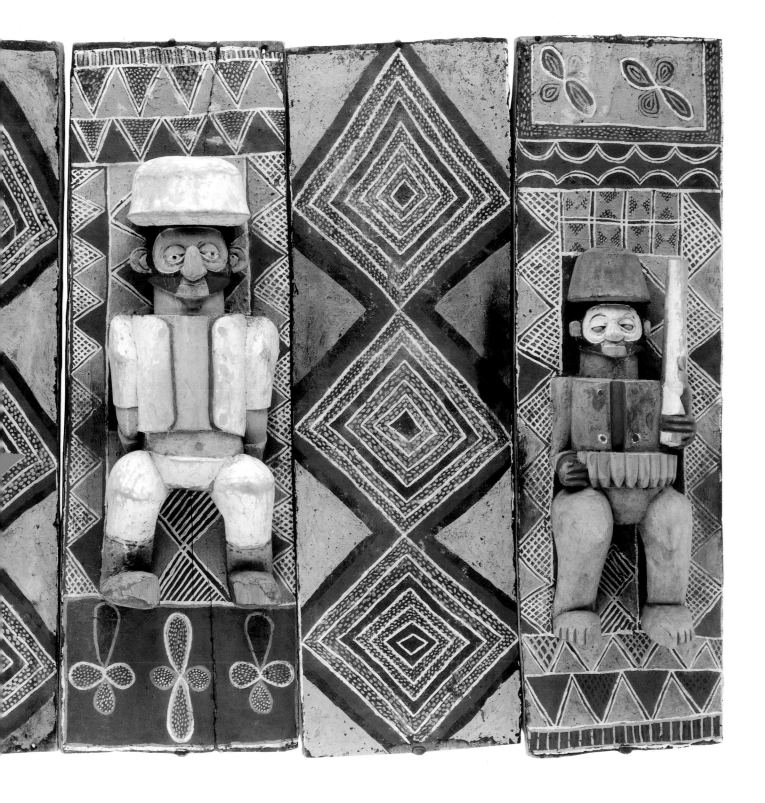

8 *Wall panels*

Nkanu peoples, Democratic Republic of the Congo
Wood, fiber, pigment
120.7 × 128.8 × 18.6 cm (47 ½ × 50 ¹¹⁄₁₆ × 7 ⅜ in.)
Africa Museum, Tervuren, RG37.325–37.331 (acquired in 1937)

Music is an important part of the *nkanda* initiation rites. In this grouping of wall panels, a drummer is accompanied by two musicians playing horns. The musicians' buttoned vests, trousers, shoes, and caps attest to the popularity of Western attire. Two panels feature animals. The checkered pattern on the body of a coiled snake killing its prey symbolizes emptiness and death. Two gray birds appearing to chase each other represent, according to informants, the circular flight pattern of the *nkumbi-nkumbi* birds,[9] which are symbolic of the recently circumcised initiates. The triangles with their bases facing each other in between the birds represent a "man and woman, separated, but living in the same house." The wheel design located above and below the birds depicts the sun or the male principle. The four-leafed flower within a square appearing on three of the panels symbolizes the female sex and is associated with crossroads. Crossroads and intersecting lines always represent the connection between different worlds.

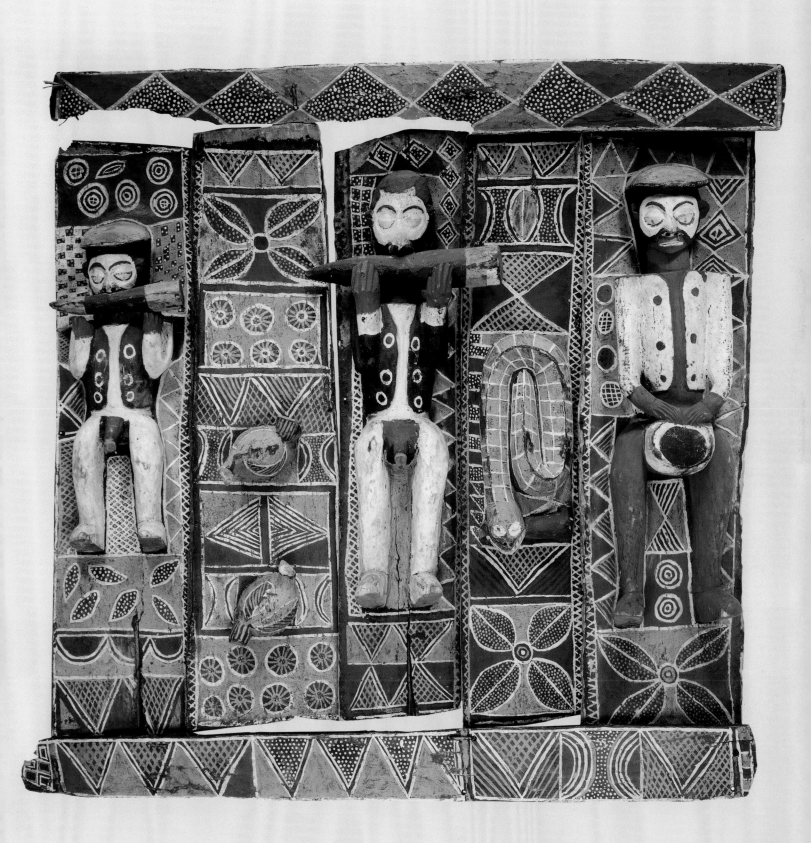

9 *Wall panel*

Nkanu peoples, Democratic Republic of the Congo
Early 20th century
Wood, pigment
91 × 33.4 × 14.5 cm (35 ¹³/₁₆ × 13 ⅛ × 5 ¹¹/₁₆ in.)
Collection of the Jesuit Fathers, Heverlee, on permanent loan to the Africa
Museum, Tervuren, 1341

The panel depicts a light brown dog sinking its teeth into a guenon monkey's long tail. To the Nkanu, the dog and the monkey represent immoral behavior. *Nkanda* participants refer to the dog as *Mbwa (ye) nkila* (the dog with the tail). A term of abuse for the uncircumcised, the tail is a metaphor for the uncircumcised penis. According to Nkanu informants, many farm animals—including dogs, goats, and hens—are the subjects of ridicule because they shamelessly have intercourse where all can see.

The guenon is a symbol of cunning, unreliability, infidelity, and promiscuity. The proverb "Big monkey, you may hide but your tail betrays you" informs all who listen that despite secretiveness and attempts to hide misbehavior, your guilt is clear. A scaly pattern suggesting a feline predator is placed between the two animals. The string of cowrie shells painted at the bottom of the board represents the female genitals.

I was able to conclude that a sculptor named Nsebani of the clan Kinkenga baka sima from Kipindi carved this panel.[10] Nsebani was born in the beginning of the twentieth century and died in 1966. He was invited to participate in many *nkanda* rituals, often with the assistance of sculptors Dimonika and Senda from Kinzanzu village. Nsebani last served as *nganga luvumbu* in an *nkanda* in 1942 in Kipindi. In the early to mid-1950s, he stopped serving as a ritual specialist because the spiritual movement of the prophet Kubansindu forbade the use of rituals and power objects. From that moment on he was active only as blacksmith, a craft he learned from his father.[11]

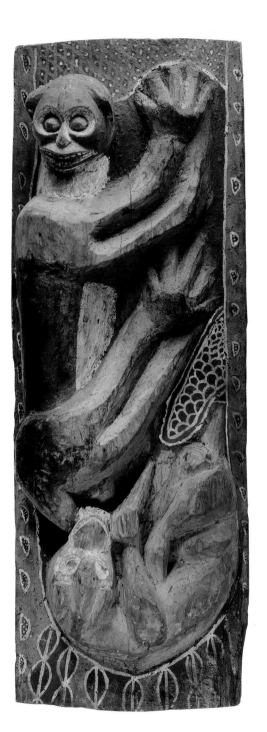

10 *Wall panel*

Nkanu peoples, Democratic Republic of the Congo
Early 20th century
Wood, pigment
94.2 × 30.4 × 17.4 cm (37 1/16 × 11 15/16 × 6 7/8 in.)
Collection of the Jesuit Fathers, Heverlee, on permanent loan to the Africa
Museum, Tervuren, 48.8.1

A coiled Gabon viper has captured a small *nsiesi* antelope. The antelope is depicted in Nkanu folktales as an intelligent, cunning, and rather cheeky character that manages to outsmart larger animals. In the context of the *nkanda,* the animal often symbolizes the initiates.

At the top of the panel is a pattern informants interpreted as the "chief's seat/neck rest." The traditional chief is the guardian of the clan members. At the bottom of the panel, a human profile in white reaches out to touch the antelope's hoof. Could this be an image of the *nkanda* healer holding the piece of wood used to support the initiate's circumcised penis? The attribute is in fact called *koso di nsiesi* or "foot of the *nsiesi* antelope." The hatched triangles in the background represent the settlements of the ancestors or the populated areas of a region. The small arcs stand for the positions of the moon, and the two rows of semicircles are symbolic of sexual abstinence—a man and a woman turning their buttocks to each other.

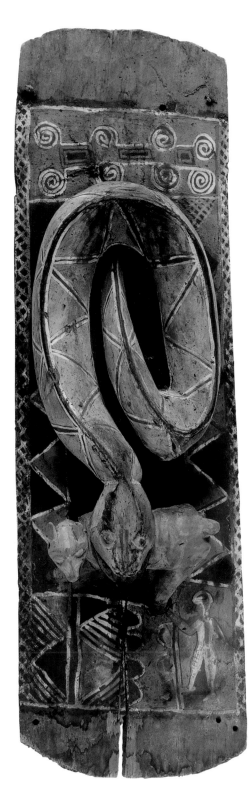

Wall panels

Nkanu peoples, Democratic Republic of the Congo
Wood, pigment
121 × 75 cm (47 ⅝ × 29 ½ in.)
Sociedade de Geografia de Lisboa, Lisbon
Not on exhibit

The photograph by F. L. Michel (fig. 38) documents a *kikaku* displaying decorated wall panels that are now in the collection of the Sociedade de Geografia de Lisboa. The wall panels depict a male and female figure with a coiled snake between them. Marie-Louise Bastin (1994: 99; fig. 78) rightly notes that the panels are "ornamented with sculpture that alludes symbolically to procreation." There are, however, also cosmic signs in the iconographic message that the artist(s) wished to convey.

Figural sculpture placed in front of the wall panels depict a seated Congolese woman and two standing men, each with an animal (presumably an antelope) draped over their shoulders. The figure on the left wearing Western-style clothing is brandishing a rifle. Successful hunters as well as their weapons and dogs are respected in Nkanu culture.[12] When Domingiele Mvwaka saw a photograph of these panels, he responded with a riddle: *Mbisi yitele tata menga nsi yakula* ("The wild animal that killed father, spreading his blood across the earth, over the entire area"). The answer is *Mvungula* or *mvungini* ("sparks"). The animal refers to a mistress, and the spread blood stands for indiscretion and adultery revealed.

The other two figures, a Congolese woman and a European man appear to have been made by a different sculptor. Perhaps the figures were intended as a pair. The artist probably wanted to represent a European man with a married Congolese woman as his mistress. The woman is seated with one hand placed on her genitals; the other hand holds a pipe. She is a mature, beautifully dressed woman wearing a bodice studded with beads. The designs on her neck as well as the lines around her wrists and ankles represent rings or strings of beads. A head post with the face of Kisokolo is placed in front of the *kikaku*.

Fig. 38 A *kikaku* in Tumba
Photograph by F. L. Michel, 1903
Archive photograph, Africa Museum, Tervuren

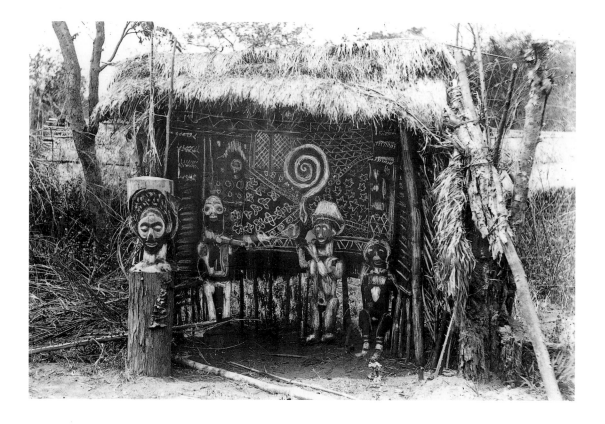

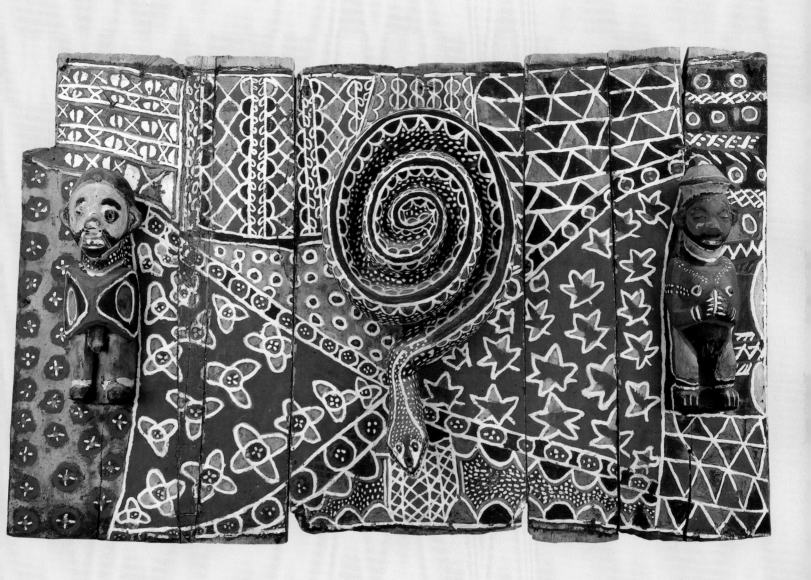

11 *Floor sculpture*

Nkanu peoples, Democratic Republic of the Congo
Wood, pigment
23.4 × 117.7 × 26 cm (9 ³⁄₁₆ × 46 ⁵⁄₁₆ × 10 ¼ in.)
Collected by Commandant Cabra
Africa Museum, Tervuren, RG200 6/6 (acquired in 1903)

This heavy wooden sculpture, painted only on the side seen by viewers, was displayed on the floor of a *kikaku* in front of the decorated wall panels. A Gabon viper threatens a growling dog while a spotted civet or genet looks on. Are we witnessing a dispute over authority or does this represent a circumcision scene?

The reptile, unmistakably a Gabon viper, was described as early as 1906 by Coart and de Hauleville (1906: 244). The depression formed by the coiled snake's body held the red pigment and oil that initiates rub on their bodies in front of the *kikaku* near the conclusion of the rite. The dog with raised tail represents the uncircumcised boy. The spotted cat probably represents the circumcised individual, while the coiled viper symbolizes the male organ.

Two chickens and a rooster, drawn on the flat surface flanking the viper, recall the hen and rooster kept within the *nkanda* enclosure.[13] Their presence is required there, just as a rooster is needed to herald the start of a new day in an Nkanu community. Their presence reminds initiates of the Nkanu proverb, "you don't want a cock; you don't want a guinea fowl; then who's going to warn you at the break of day?" Or worded another way: "You don't want to listen to good advice, but who's going to lead you then?"

A band of semicircles on the floor of the sculpture is suggestive of the feline's tail and represents either the positions of the moon or sexual abstinence—a man and a woman turning their buttocks to each other (see cat. 10). The linked triangles stand for sexual intercourse: the male and female genitals fitting together. The checkerboard pattern refers to cultivated land. The scaly pattern on the cat's back represents its spotted skin.

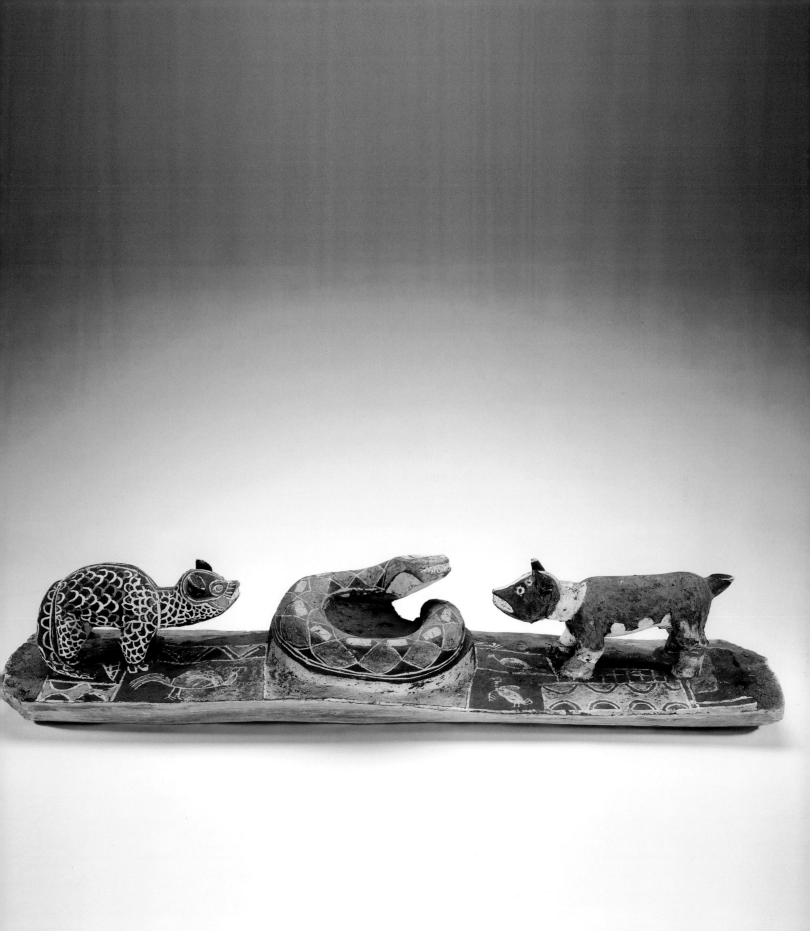

12 *Panel*

Nkanu peoples, Democratic Republic of the Congo
Wood, pigment
36.6 × 24 × 10.2 cm (14 ⁷⁄₁₆ × 9 ⁷⁄₁₆ × 4in.)
Africa Museum, Tervuren, RG39.960 (acquired in 1942)

To promote their skills and command of the visual language of initiation arts, Nkanu artists carve small models of *nkanda* masks. Clients commission works of art from the models on view in the artists' workshops. These masks are flat on the back and cannot be worn.

The bright red face, the hollow eye sockets, and the bulging cheeks with tattoos identify the masquerade figure Kakungu. The concave cavities, creating the hollow eye sockets, announce Kakungu is blind— *"Kakungu ye meso fwa,"* ("Kakungu with the dead eyes"). Kakungu is associated with the Nkanu proverb "red eyes wide open, ears closed" *("Meso matundu, makutu mahuku-huku"),* which refers to a person who can see but will not listen. In the context of *nkanda,* Kakungu reminds the initiates to obey the rules of the initiation or pay the price of blindness (ignorance) for disobedience.

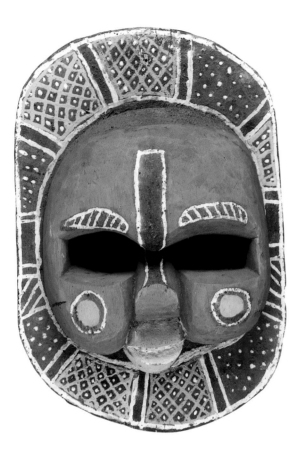

13 *Panel*

Nkanu peoples, Democratic Republic of the Congo
Wood, pigment
42.2 × 22 × 11.2 cm (16 ⅝ × 8 ¹¹⁄₁₆ × 4 ⁷⁄₁₆ in.)
Africa Museum, Tervuren, RG48.27.29 (acquired in 1948)

The head, bordered by a raised edge and cut in
relief in a small panel, delineates the style of a
Kisokolo mask as it is crafted in the eastern part
of the Nkanu region.

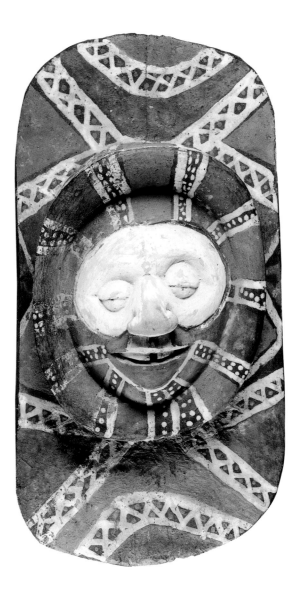

14 *Panel*

Nkanu peoples, Democratic Republic of the Congo
Wood, pigment
40.8 × 25.1 × 11.5 cm (16 ⅟₁₆ × 9 ⅞ × 4 ½ in.)
Africa Museum, Tervuren, RG39.959 (acquired in 1942)

Although published accounts have identified similar images as owls' heads, informants remarked on the resemblance between the African gray parrot's curved orange beak and prominent eyes and the features depicted on the panel. Parrots' eyes are considered aphrodisiacs possibly because the Nkanu identify eyes and beaks with the male sex.

According to informants, this panel also represents Kakungu, which explains the panel's somber palette (black/gray, white, red/orange).

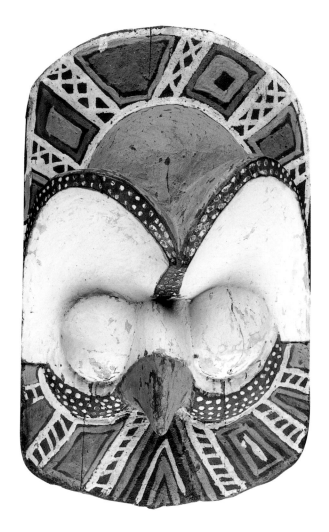

15 *Panel*

Nkanu peoples, Democratic Republic of the Congo
Wood, pigment
29.4 × 24.2 × 9.5 cm (11 ⁹⁄₁₆ × 9 ½ × 3 ¾ in.)
Africa Museum, Tervuren, RG39.961 (acquired in 1942)

What appears to be a hybrid image is in fact an
elephant. The animal raises its trunk, with its tusk
turned inward. The ears are uncharacteristically
small. The Nkanu associate the elephant with greed
and destructiveness as well as the positive attributes
of male virility. The tusks may also have phallic
connotations.[14]

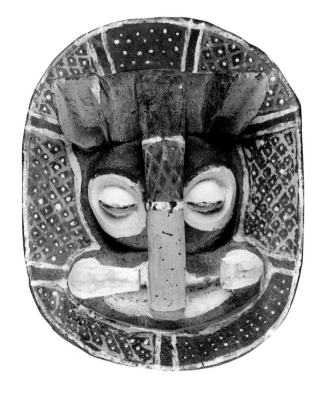

16 *Standing female figure*

Nkanu peoples, Democratic Republic of the Congo
Early 20th century
Wood, pigment
35.2 × 11.3 × 9 cm (13 ⅞ × 4 ⁷⁄₁₆ × 3 ⁹⁄₁₆ in.)
Collection of Marc Leo Felix

This small figure depicts a beautifully dressed young
Nkanu woman. The painted bands at the top and
bottom of the torso delineate the festive bodice
(kibika) and bead-studded skirt *(mpaka).*[15] The
patterns of triangles filled with dots refer to both
sexes as well as to sexual intercourse. The female sex
is represented by an upside-down triangle, while the
male sex is symbolized by a right-side-up triangle.
Touching triangles represent sexual intercourse,
while patterns of transposed triangles allude to the
movements made during sex as well as sexual arousal.

The figure's hands rest on her belly, indicating
she may be pregnant and is communicating with the
baby in her womb. Note her closed eyes: the sculptor
probably wanted to suggest that the woman has been
misled. The Nkanu say, *"Zima meso. Bakuyika
makaya; nkinga ma menga ga koko, ma e ata kubonga
mawu"* ("That they give you more meat, while they
steal the meat that is still in your hand").

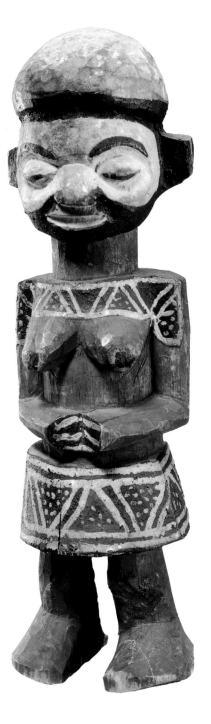

17 *Mother and child figure*

Nkanu peoples, Democratic Republic of the Congo
Early 20th century
Wood, pigment
48.5 × 14.5 × 13.3 cm (19 ⅛ × 5 ¹¹⁄₁₆ × 5 ¼ in.)
Collection of the Jesuit Fathers, Heverlee, on permanent loan to the Africa
Museum, Tervuren, 2748

Small figures like these are occasionally placed within
the *kikaku,* but are more often found in the homes
of individuals with fertility problems. The figure
of a woman carrying a child on her hip signifies
maternity, fertility, and the pride of motherhood.
The expression *"kusa mwana ga magembo"* literally
means "placing [of the] child on one's hip."[16]

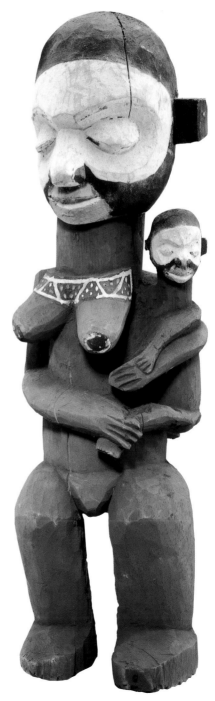

18 *Standing female figure*

Nkanu peoples, Democratic Republic of the Congo
Wood, pigment
51.4 × 14.2 × 16.3 cm (20 ¼ × 5 ⁹⁄₁₆ × 6 ⁷⁄₁₆ in.)
Africa Museum, Tervuren, RG48.27.7 (acquired in 1948)

This figure most likely represents a European nun.
The egg-shaped head is painted white with large eyes,
a wide nose, and full lips. She is wearing religious
clothing—a veil covering the top and back of her
head, a long robe, and black shoes. Her hands resting
on her abdomen can be interpreted as a gesture of
humility, one of prayer, or an imploring pose.

The figure may have been included in a larger
narrative scene within the *kikaku,* perhaps with the
intention of mocking or ridiculing European religious
orders. Because Europeans were frequently mocked,
it is conceivable that the artist wanted to suggest the
nun was pregnant.

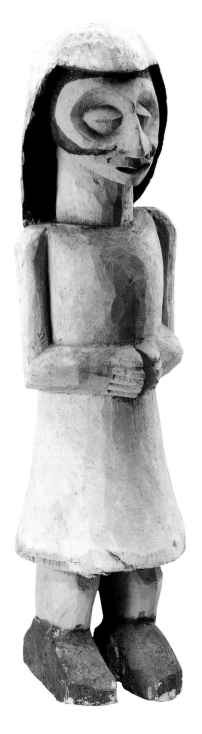

19 *Drummer figure*

Nkanu peoples, Democratic Republic of the Congo
Wood, pigment
71 cm (28 in.) high
Collected by Commandant Cabra
Africa Museum, Tervuren, RG200 6/5 (acquired in 1903)
Not on exhibit

This well-known figure of the drummer was created by the same artist who sculpted the standing male and female figures (cat. 20), the Makemba mask (cat. 25), and the floor sculpture (cat. 11). No information is available about the artist who created these works. The drummer figure was part of a floor sculpture display in front of the decorated wall panels in a *kikaku*.

The musicians who play the one-sided dance drum perform at the start of *nkanda* and during the final phase of the ritual when they accompany the masquerade performances. *Kusika ngoma* and *kubula ngoma* mean "beating the dancing drum." The Nkanu also speak of *kubunda ngoma* and *kubetika ngoma* when the drummer announces the start of a gathering.

The black circle on the drumhead represents the resin the musician applies to the drum before playing. This resin, which is heated, tightens the drumhead to create the right tone. The drum, which is clasped between the musician's legs, usually hangs from a rope or a band of cloth tied around his waist. The drummer usually wears *nkoka* fruit around one or both wrists. The seeds in the globular fruit produce a rattling sound when the percussionist plays the drum.

This exquisite carving was not meant to be seen exclusively from the front and offers new, and often surprising, perspectives when viewed from various angles. The slight asymmetry of the sculpture, the way the figure turns its face slightly away, and the rounding of its back evoke action. Like a photographer, the sculptor was able to create a dynamic snapshot of a musician as he is performing. His head is turned as he carefully listens to the tone of his instrument, which is accompanied by the sound of the seed rattles on his wrists.

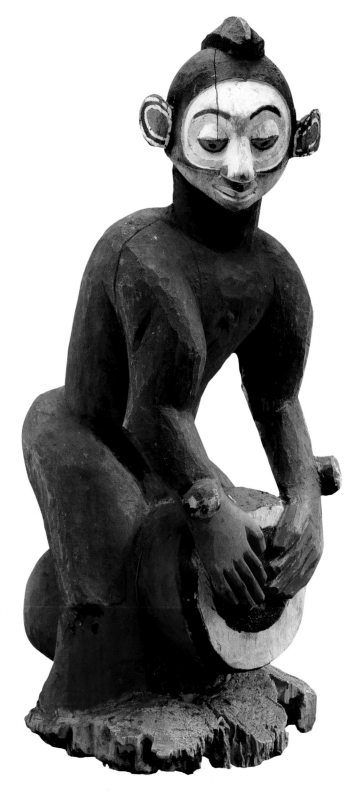

20 *Male and female guardian figures*

Nkanu peoples, Democratic Republic of the Congo

Wood, fibers, resin, hair, pigment

Female figure (RG200 6/2): 101.4 × 27 × 46.5 cm (39 ¹⁵⁄₁₆ × 10 ⅝ × 18 ⁵⁄₁₆ in.)

Male figure (RG200 6/2): 99.1 × 30.2 × 26.5 cm (39 × 11 ⅞ × 10 ⁷⁄₁₆ in.)

Collected by Commandant Cabra

Africa Museum, Tervuren, RG200 6/2 & RG200 6/1 (acquired in 1903)

Judging from their large size, these two figures probably stood at the entrance gate to an initiation enclosure. These figures were sculpted by the same artist who made the well-known drummer (cat. 19) and may have been sculpted for the same *nkanda*.

The female figure places her right hand on her stomach. In her left hand she clutches a bundle of twigs that may refer to the part of the initiation rite when the initiates are chastised *(kusengula)* with twigs. She is depicted wearing a beaded bodice, a skirt decorated with strings of beads, and bracelets.

The male figure lifts one hand, while putting the other in front of his mouth.[17] Nkanu informants interpreted the figure's gesture as threatening and one of reproach. In the Nkanu dialect, placing a hand on or in front of one's mouth is called *kukanga nwa,* which literally means "the closing of the mouth." The expression *kabata-kabata* is defined as an imposed silence or mandatory secrecy. The figures, therefore, might be a reminder of the secrecy surrounding the initiation process and the initiates' oath to protect the secrecy of *nkanda.*

A completely different interpretation suggests the male figure was originally holding a musical instrument, probably a horn, and, judging from his uniform, may have been a member of a military band. The theme of musicians occurs elsewhere in *nkanda* sculpture (see cat. 8).

Both figures wear raffia skirts, which are meant to hide their detailed genitals until they are suddenly revealed to the great amusement of the initiates. While such behavior outside of initiation would be considered offensive, these reservations are set aside during *nkanda*, which, after all, revolves around the concept of fertility.

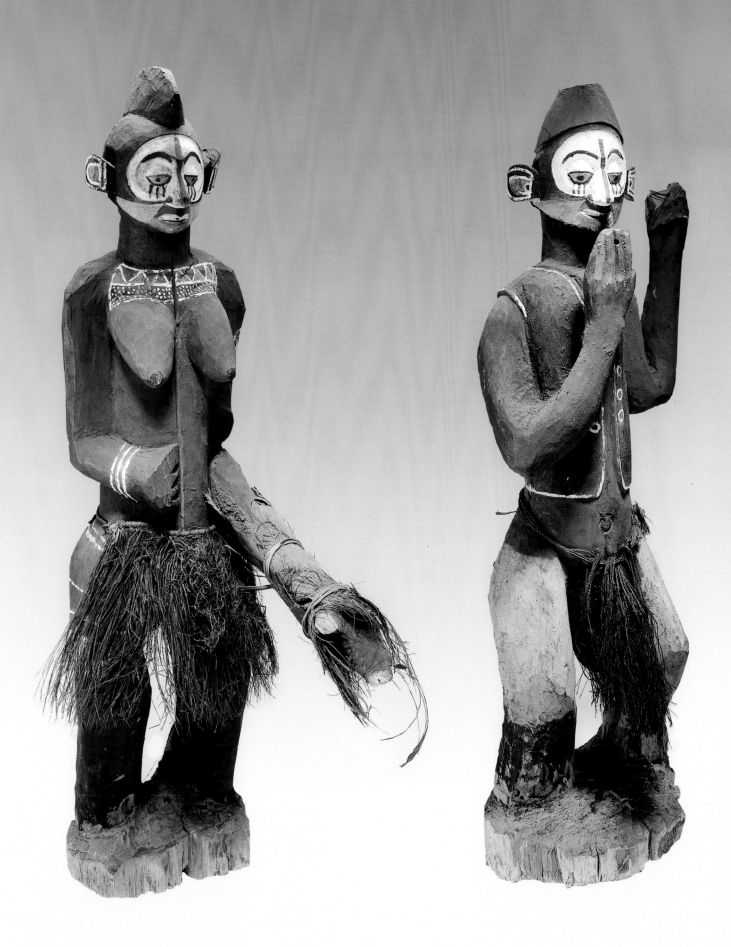

21 *Leopard figure*

Nkanu peoples, Democratic Republic of the Congo
Wood, pigment
43.5 × 19.5 × 41cm (17 ⅛ × 7 ¹¹⁄₁₆ × 16 ⅛ in.)
Africa Museum, Tervuren, RG48.27.43 (acquired in 1948)

This sculpture would have been displayed on the floor of the *kikaku* in front of the wall panels to remind initiates to respect authority. The animal's size and fierce counternance give it an imposing presence. The sculptor gave this leopard hooves, instead of paws, and human eyes, ears, and nose. The scaly pattern covering the head and body represents the spots of a loepard or other feline.

Leopards, civets, or genets are metaphors for traditional leaders who have the right to wear the skins of these predators. In central Africa, the leopard is *the* metaphor for traditional leaders. *"Nsi bamfumu, ngo ka bakundianga ye n'kanda ko"* (In the land of the chiefs, the skin is not eaten along with the leopard), which means, when a leopard or smaller feline predator is killed, the skin of the animal, by rights, belongs to the traditional chief.

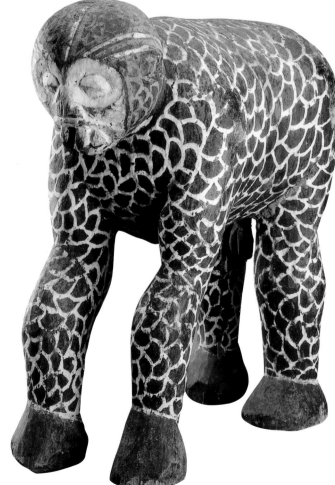

22 *Leopard figure*

Nkanu peoples, Democratic Republic of the Congo
Early 20th century
Wood, pigment
24.2 × 75.1 × 22.6 cm (9 ½ × 29 ⁹⁄₁₆ × 8 ⅞ in.)
Collection of Donald and Adele Hall

This figure, similar to the leopard in the collection
of the Africa Museum, Tervuren (cat. 21), was
displayed in front of the decorated wall panels in
a *kikaku*. Its mouth is open to reveal menacing
teeth, and the head is crowned with raised eyebrows
decorated with parallel lines and dots. Despite the
owl-like appearance of the animal's head, this is not a
composite animal. Most representations of leopards
display the same stylistic conventions.

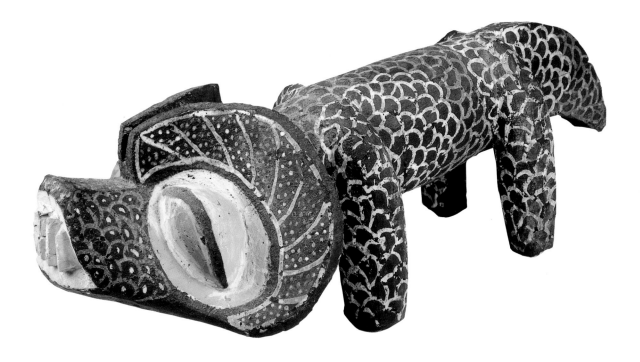

Nkanda masks

Michel Plancquaert was the first to identify the creative output of the Nkanu as a distinct art form. He cautioned, "One should be careful not to attribute to the Bayaka [Yaka] certain masks that are used by the Bankanu" (1930: 112; figs. 48, 50) and disclosed the Nkanu masks most striking feature, namely their monumentality (fig. 39). The enormous dimensions apply primarily to the large bulbous headdresses and less to the sculpted portion of the masks.

An Nkanu mask consists of: a human or animal face or mask with a figure carved on it; a large fiber headdress; and a raffia collar, suspended from the lower edge of the mask, that hides the dancer's face. A cap resting on the dancer's head inside the superstructure adjusts the mask's placement so the dancer's vision is unobstructed. This design—known as a half helmet mask—differs from Yaka dance masks that have a handle which the masked dancer holds or a piece of string or stick that the dancer

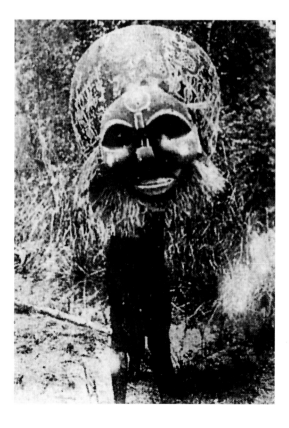

Fig. 39 Nkanu wearing a Kakungu mask
Photograph by Father G. Dumont
In M. Plancquaert, *Les sociétés secrètes chez les Bayaka* (Louvain: J.Kuyl-Otto, 1930), fig. 50

clenches between his teeth to keep the mask in place. Nkanu and Yaka masks are also distinguished from one another by their proportions. Nkanu masks feature a large wooden component and a close-cropped fiber collar. Yaka masks, on the other hand, feature a small, sculpted element and a long raffia collar.

The four principal *nkanda* masks are Nkoso, Kakungu, Kisokolo, and Makemba: one of each type must be present during *nkanda*. The masks, with the exception of Nkoso, are made from the wood of the umbrella tree, which is lightweight and, despite the masks' considerable size, allows the wearer to move and dance freely. The dramatic differences in the sizes of *nkanda* masks are illustrated in figure 40.

All Nkanu masks, with the exception of Nkoso, have a bulging headdress—a billowing armature of twigs attached to the face mask. The woven skeleton is covered with locally manufactured raffia cloth or, more recently, burlap. The headdress is then stuffed with plant matter: straw, dried banana, or palm leaves. Before painting the headdress with colorful designs and symbols, the surface is covered with black resin.

The mask maker creates a specific type of mask by shaping the headdress and adding elements like horns or feathers. A bulbous headdress, for example, is typical of the Kakungu mask. A colorful crown of feathers embellishes Nkoso, while curving "horns" represent Kisokolo. Small, carved, wooden figures appear on the forehead or face of other Nkanu masks, including Makemba, Ndele, Mangombo, and Kikenena. The Makemba mask represents a pregnant woman or a mother with child; the Ndele mask, a European man;[18] the Mangombo mask, a diviner; and the Kikenena mask, a laughing character. The Nkanu also produce a variety of animal masks.

Although only a limited number of Nkanu masks exist, making it difficult to identify specific styles, we can draw some general conclusions. For example, the wooden head masks from the western Nkanu region are often bigger (fig. 41), while those

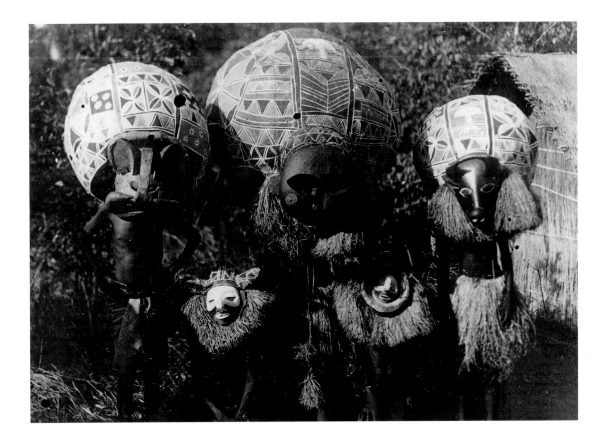

Fig. 40 Nkanu initiates wearing initiation masks
Left to right
Back row: Elephant mask, Kakungu mask, goat mask
Front row: Kisokolo mask, Kisokolo mask
Photograph by Father Pauwels
Archive photograph, Africa Museum, Tervuren

in the southeastern region and northern Angola have a raised edge surrounding the mask face or are carved in high relief or on a concave plate (see cats. 13 & 27).

All *nkanda* masks—animal and human—educate initiates in aspects of human behavior, both desirable and undesirable, as a way to prepare the youths for their roles as responsible, productive adults. The most important masks also represent ancestral spirit forces that sanction the initiation process and protect the young men during the rite.

Among the Nkanu a mask is called *nkisi mi kutukila ku nkanda,* which literally means "power figure for departure from the *nkanda.*" Like the initiation panels, the masks ensure the smooth course of the crucial stage at the end of the *nkanda,* when the initiates are symbolically reborn. They are objects of power *(minkisi)* because they are given certain magical properties by the specialist sculptor who chews a cola nut, beats the face of the mask with twigs, and speaks to it, which is believed to give the masks power. [19] This is the only ritual practice associated with a mask.

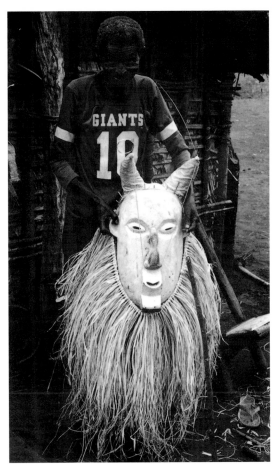

Fig. 41 Ignace Mayimuna Magebuka displaying a mask with raffia collar, 1991

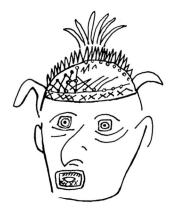

Fig. 42 Nkoso mask; drawing by a sculptor nick-named Sunday

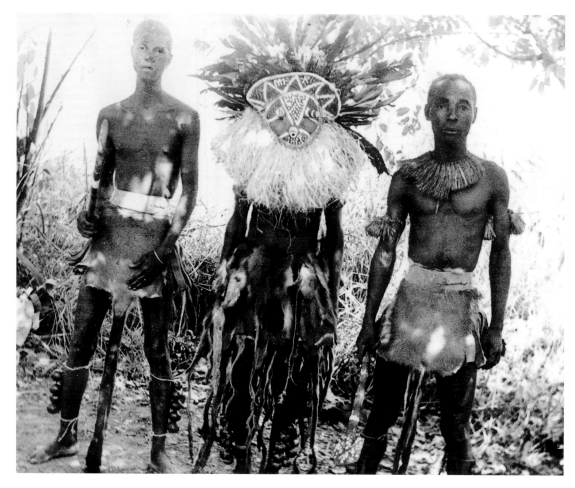

Anthropomorphic masks

Nkoso

The Nkoso mask from the western Nkanu region has a wooden face with human features. The head-dress—a cap woven from raffia fibers strengthened with twigs and painted with dyes (mixed with resin)—is decorated with a colorful variety of blue-green, spotted feathers.[20] The feathers pierce the woven cap. The shafts are tied together at the bottom with raffia strings and a layer of resin secures the feathers in place. I do not know of extant examples of this mask type. (Figure 42 shows a rough sketch of the mask by an Nkanu sculptor.)

The Nkoso mask is better known in a style that consists of a woven, trapezoid raffia hood which fits over the dancer's head and has a wide, colorful feather headdress (figs. 43 & 44). The eyes and mouth are made from the stems of a small gourd and are attached to the mask with resin. Small openings under the eyes permit the masked dancer to see. The shape is reinforced at the bottom by means of a stiff vine (liana) bent into a circle. A raffia fiber collar is attached to the bottom edge of the mask.

The Nkoso mask's colorful crown of feathers suggests that it represents a bird or at least that the

Fig. 43 Alias Marker with an Nkoso mask, 1974

Fig. 44 An Nkoso mask made by Nsiabula Malungidi and Marcel Kahuma, 1990

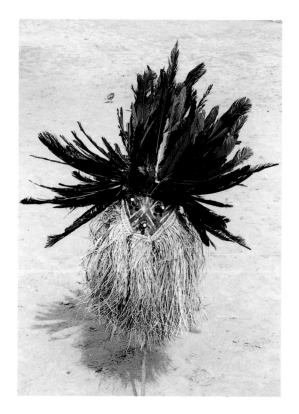

"being" it evokes derives its ability to fly from birds. Like a bird, Nkoso can cross boundaries. The mask always accompanies the initiates whenever they leave the enclosure. An elder wearing the mask leads the initiates from the place of initiation to the rivers or fields near the enclosure. The same elder also opens the *kikaku,* the enclosure that displays the polychromed wall panels and sculpture. When the initiates leave the enclosure for the last time, the Nkoso mask can be worn by any newly initiated boy.[21]

During performance, the Nkoso masked dancer carries a staff, a flywhisk, or a sword.[22] The audience draws back when Nkoso enters because he menacingly lashes out, to the laughter of the bystanders, at the uncircumcised boys. Those who are hit by Nkoso's weapon must pay a fine or be tended to in order to avoid serious problems.

Kakungu

The largest mask created by the Nkanu is Kakungu, an important mask form also made by the Yaka and Suku (see figs. 39 & 40). Together, the face and headdress have an average height of about seventy centimeters. Tradition dictates that the collar hanging down from the wooden mask must consist of mashed fibers from the *futi* (Entada gigas) liana.[23]

Kakungu masks sometimes have exaggerated facial features. The physiognomy of the mask is meant to impress the audience and inspire fear through its size, its empty eye sockets or shriveled eyeballs, and its exaggeratedly round cheeks and red face.[24] The latter two are symptoms of severe malnutrition, which suggests to the initiates that the *nkanda* enclosure is a place of hunger.[25] The gaping eye sockets of Kakungu warn those who break initiation rules that they will be struck blind. Domingiele Mvwaka described Kakungu as a blind old man, but he was unable to identify the character more completely.

The most striking element of the Kakungu mask is certainly its large, bulbous headdress (cat. 23, see figs. 39 & 40). Reportedly, it represents a giant termite hill, with the sun rising on one side and setting on the other. Sun imagery usually also appears in the large subdivided circles on both sides of the headdress. The termite hill has an important place in the world view of the Nkanu: the earth and the ancestral world are represented as two termite hills opposite one another. Informants declare termites may fly out of a Kakungu headdress when somebody taps it or during a dance performance. These white flying ants are symbolic of the ancestral spirits within the Mpemba world and the initiates living a dormant

life within *nkanda.*[26] Presumably, the termite colony is considered a reflection of the *nkanda* community: both are governed by a blind leader. The Kakungu masked figure also bears the title of "reine des insectes" ("queen of the insects").

Nkanu informants unanimously agreed Kakungu is the oldest mask form and a true Kongo creation. This implies that there is a certain hierarchy among the masks. The superior position of Kakungu is connected with the fact that the mask is worn by the leader of the initiates, Mbala, the last boy to be circumcised.

Kabunga, the "chef de terre" and ancestor of all *bitome,* is present in Kakungu. Both Kakungu and the *kitome* are said to possess an ambivalent power that can heal or harm a person and control the forces of earth and weather. Kakungu is credited with the ability to control the weather—Kakungu can fend off storms and bring rain during long droughts. We also know Kabunga is a descendant, on his father's side, of the original population, the Mbaka-mbaka. The large dimensions of Kakungu's head,[27] his reddish brown complexion, his puffed-up cheeks, and chin are physiognomic characteristics the Nkanu connect with the Mbaka-mbaka[28] and the Nsamba.

The Nkanu also produce a female counterpart, called Nzondo,[29] to Kakungu. During the performance of Kakungu at the departure celebration, the masked dancer sprinkles the audience with a liquid that contains, among other things, elephant manure. Asked about the relationship between the largest land mammal and the Kakungu mask being, the artist Domingiele Mvwaka replied that both are important chiefs. After the dance, three little horns filled with magical ingredients and feathers sticking out of them are thrown at Kakungu's face. The feathers vibrate when the mask is struck, which reinforces the frightening aspect of Kakungu.

Kisokolo

Kisokolo is a masked figure that is popular with Nkanu audiences (cat. 24, see fig. 40). The Kisokolo mask is recognized by its white face, a facial tattoo in the shape of glasses (*n'ganzi* tattoo[30]), and a prominent, upturned or hooked nose. The mask's open mouth displays teeth that have been filed or cut. The bulging headdress, built from twigs and woven cloth, displays two curved "horns," that are connected to the nose with a string. A fibrous knot or piece of animal skin sometimes protrudes from the top of the "horns." The "horns" represent the raised arms of a dancer expressing his joy. A piece of *nzusi* skin or a strip of fur from another spotted feline

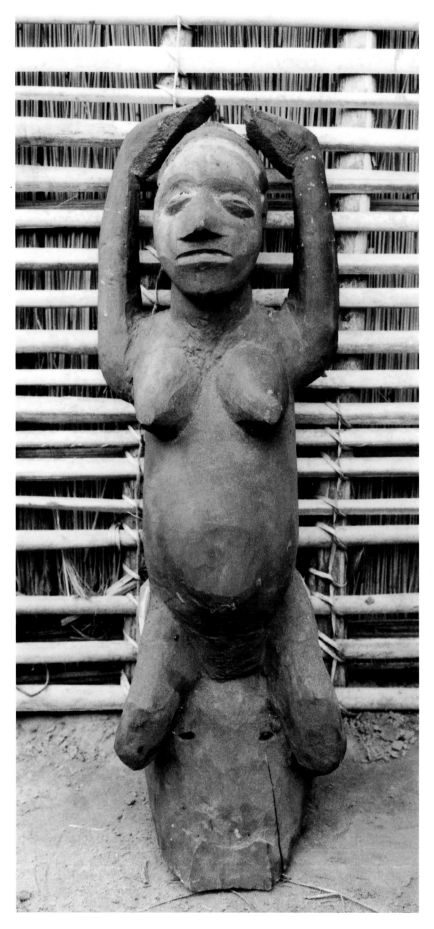

Fig. 45 Makemba mask, in the form of a pregnant woman, without its headdress and raffia collar. Made by Marcel Kahuma, the mask was used in an *nkanda* in Kingala, Angola, 1991

predator[31] is often placed between the horns. Sometimes it is replaced with a painted representation of an animal skin, a raffia brush, or a crest running over the top of the mask.

The name Kisokolo may be related to the Chokwe word *cisokolu,* a forked, Lunda hunter's staff, to which amulets are attached. There may also be a connection to the mask's long nose. I suspect the shape of the nose originally had a functional role. Van Wing notes that the initiates had to eat a piece of manioc bread and goat's meat from the nose of a (feathered) mask (1921: 369). The hooked nose of Kisokolo seems eminently suited to such a purpose. Moreover, the full name of the mask is "*Kisokolo kudidi mbumba"* ("Kisokolo who ate the injunction"). For the Nkanu, this detail may represent an elephant's trunk[32] as well as a phallic symbol. The idea of the nose as an erect phallus correlates with Kisokolo's reputation as a womanizer. When the mask appears, the following song is sung:

> Eh, young Kisokolo, ye . . . eh!
> Thing beloved of the Kongo people!
> Manioc pudding? Let's put it away!
> Peanuts? Let's put them away!
> Money? Let's put it away!
> A woman? Let's give her this!

Kisokolo may be a dancing chief. During *nkanda* masquerade performances, he dances with Makemba, the sorrowful feminine masquerade figure.

Makemba

Makemba is the name given to a face mask with feminine features and to a mask that has a female figure carved on the wooden face mask. Makemba represents a pregnant woman (cat. 25, fig. 45) or a mother of one child or twins. The mask of the mother of twins is greeted as *mama bole* (mother [of] two.)

Etymologically, Makemba is a combination of *ma,* a respectful title for a woman, and *kemba* (or *kukemba*), "to rejoice." A song that is sung when Makemba performs asks the mask to be content with the child she is bearing ("Eh, receive the child for me in joy, eh . . . eh!"). Although Makemba is expected to rejoice in motherhood, the masked figure is considered to be a very sad character, possibly mourning the symbolic death of the initiates as they participate in *nkanda.* The mask's white face and the vertical lines on the cheeks have been interpreted several ways. A white face links Makemba to the world of ancestral spirits and the vertical lines under

the eyes suggest tears shed over the pain the initiates endured in the *nkanda* enclosure or grief at the close of *nkanda*.[33] In another interpretation, the white refers to the kaolin that the traditional chief and the *ndona*[34] rub on their faces as a token of their appointment by the ancestors and clan members to fulfill their respective tasks in the future.

The Makemba masked figure often appears with Kisokolo. Their performance is accompanied by sensual movements and erotic songs. On these occasions Makemba and Kisokolo seem to perform as counterparts: Kisokolo's performance is joyful, while onlookers step forward to embrace Makemba and share in her sorrow. The following song may accompany the masquerade figures performance:

> Makembi, ye, ye . . . eh!
> Ah, Elder, e . . . eh!
> Ah, look behind you,
> I see no mother!
> Ah, look in front of you,
> I see no father!
> I suffer,
> I miss my kin!

A number of other anthropomorphic masks are also made by the Nkanu, and multiple examples of these may appear during *nkanda*. The (Mu)Ndele mask (fig. 46) represents a human figure that is carved on the wooden face of the mask. The sculptor of the Ndele mask, Marcel Kahuma of Kisoma, wanted to capture the characteristic features of a Westerner, such as pale skin, hair, beard, mustache, and Western-style clothing. The Mangombo mask is similar to the (Mu)Ndele mask and represents a male or female diviner *(nganga ngombo)*. According to sources, this face mask has human characteristics or is a full, seated figure summoning *nkisi ngombo* with a rattle. I know of no extant examples of this mask or of the Kikenena mask said to represent a laughing character.

Animal masks

In addition to anthropomorphic representations, the Nkanu create several masks depicting animals of the savanna and forest. The most frequently published Nkanu mask is probably that of a leopard (cat. 26). Other masks depict antelope, hippopotamus, wild boar, elephant, and buffalo. Masks portraying the goat, the guenon, and the bird are known to have been created, although there are no extant examples.

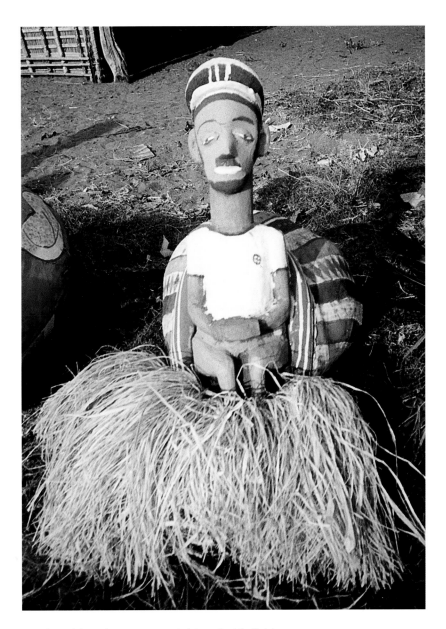

Fig. 46 Ndele mask representing a Belgian colonial official by Marcel Kahuma, 1990

According to informants, the woodcarver would prove his skills as a sculptor by making any animal he had in mind or one commissioned by an initiate. Still, it seems that the choice of animal representations was limited to those with a particular metaphoric significance. The hippopotamus, for example, is symbolic of someone looking for an extramarital relationship. The following song accompanies the hippopotamus' performance:

> Eh, despite the joy I'm expressing,
> I can find nothing to eat in the river where I live!
> I gather nothing here!
> Eh, Elder!

23 *Kakungu mask*

Nkanu peoples, Democratic Republic of the Congo
Early 20th century
Wood, fiber, cloth, pigment
64 × 40 × 34.2 cm (25 ⁷⁄₁₆ × 15 ¾ × 13 ⁷⁄₁₆ in.)
Collection of Corice and Armand P. Arman

The red face, large gaping eye sockets, and bulging
headdress identify this mask as Kakungu. The small
red eyeballs float in the oversized orbits, and holes
have been bored through the eye sockets, allowing
the dancer to see. The concave area of the eyes
contrasts with the bulging mass of the cheeks and
the accentuated volume of the forehead. The almost
sickle-shaped cheeks look like curved horns running
from the block-shaped ears to the base of the nose.
The nose widens downward and is bound at the
bottom by the "laughing" mouth. The high head-
dress, which widens toward the top, has been painted
with numerous designs in white, ochre, red, and
blue. Both sides have been decorated with a solar
wheel *(ntangu).* A thick raffia collar is attached to
the bottom of the mask.

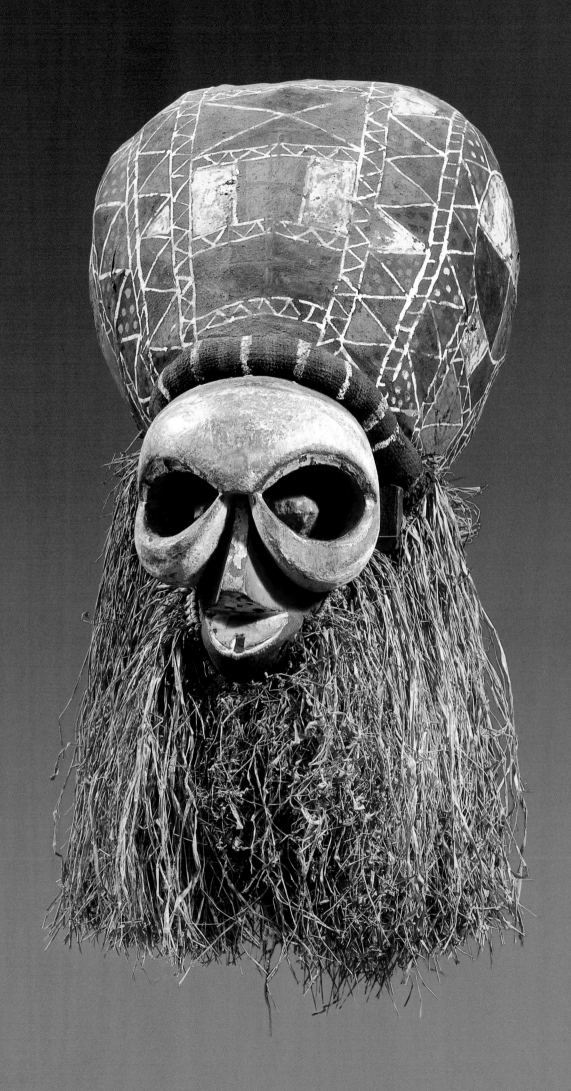

24 *Kisokolo mask and costume*

Nkanu peoples, Democratic Republic of the Congo
Wood, fiber, cloth, pigment
98 cm (38 ⁹⁄₁₆ in.) high
Collected by Sophie von Uhde in 1934
Institut für Ethnologie der Universität Göttingen, Abteilung
Völkerkundliche Sammlung, AF2237 (acquired in 1939)

This Kisokolo mask is identified by a white face with
n'ganzi tattoo pattern, rectangular ears, heavy lidded,
half-closed eyes, and a prominent upturned nose.
The helmet-shaped headdress has two forward-
projecting "horns" tipped with fiber tassels and a
raised raffia crest. The coarsely woven jacket is
trimmed with a thick raffia fiber collar and skirt.
Two braided strands ending in raffia pompoms can
be compared to the decoration on raffia clothing
worn by dignitaries at the time of the Kongo Empire.

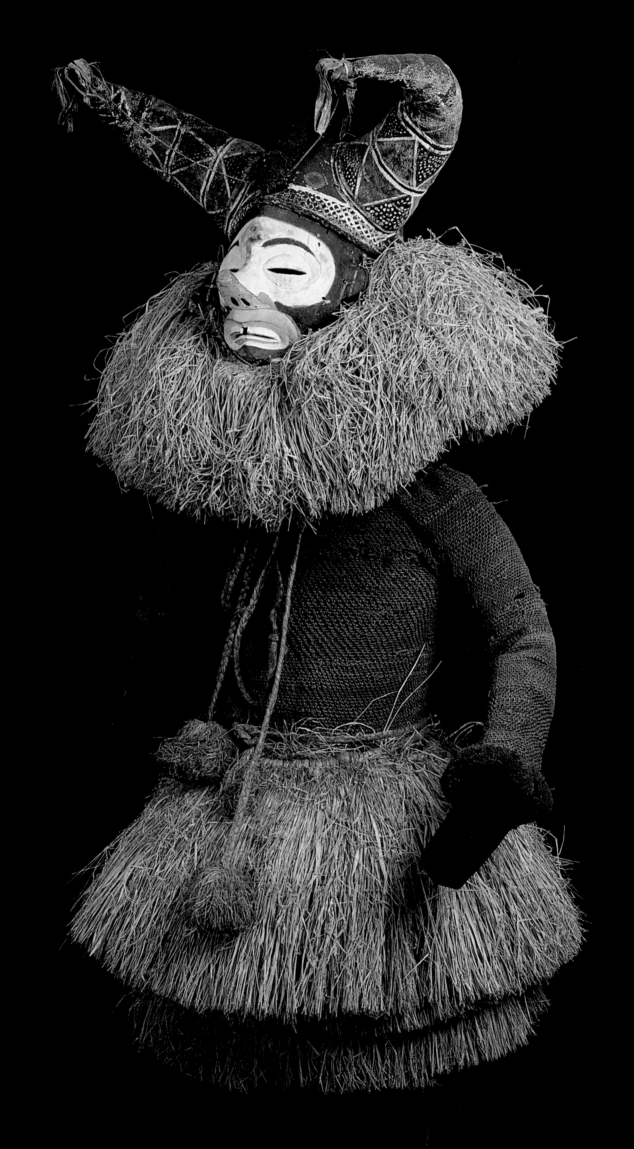

25 *Makemba mask*

Nkanu peoples, Democratic Republic of the Congo
Wood, fiber, cloth, pigment
41.4 × 51.5 × 47.5 cm (16 ⁵⁄₁₆ × 20 ¼ × 18 ¹¹⁄₁₆ in.)
Collected by Commandant Cabra
Africa Museum, Tervuren, RG205 11/11 (acquired in 1903)

This is most probably a Makemba mask. The teardrop-shaped face consists of a layering of different shapes. The *n'ganzi* tattoo pattern—an oval, white plane on a black surface—sits above the red lower jaw, from which a pink and gray mouth protrudes. The semi-globular eyes in the white plane are bisected by black lashes. The eyelids are white, the eyeballs yellow with dark pupils, and the bean-shaped eyebrows above them black with white crosshatching. There are three lines underneath the eyes. The nose ends in a blunt tip and has nostrils drilled at the base. The dark philtrum connects the nose with the open mouth, in which the teeth are set, separated by incisions and a gap (broken incisors) in the middle of the upper row. The lobe-shaped ears stand out from the head. The refinement of the face, the way the ears are cut, and the yellow eyeballs suggest that this mask was made by the same sculptor who carved the male and female guardian figures, the floor sculpture, and the well-known Nkanu drummer figure (cats. 11, 19, & 20).

The headdress has three crests set crosswise on the head. In order to construct the crests, bent twigs were attached to both sides of the face. After covering the frame with raffia cloth, the sculptor painted the surface with geometric designs. Finally, he attached a heavy raffia collar, trimmed straight at the bottom.

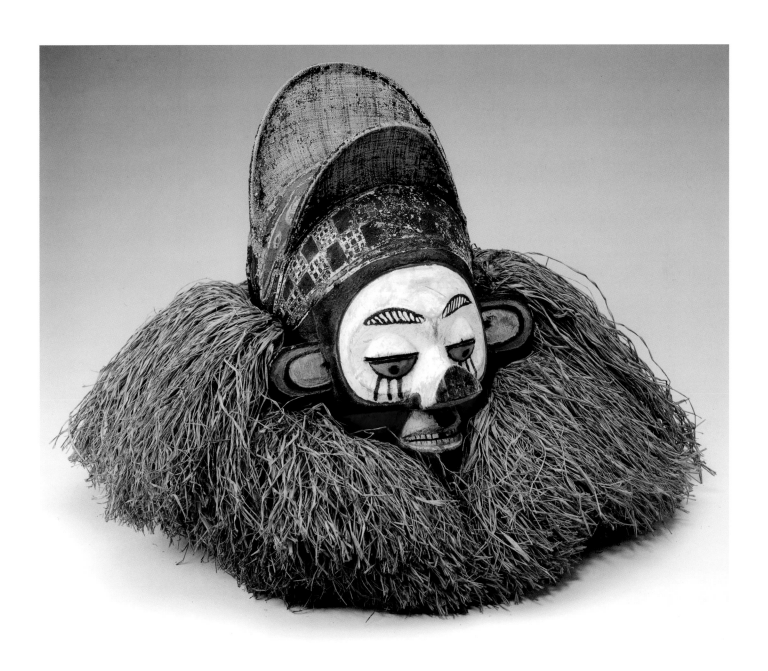

26 *Leopard mask*

Nkanu peoples, Democratic Republic of the Congo
Early 20th century
Wood, fiber, cloth, hide, pigment
66.5 × 82.5 × 80.6 cm (26 ³⁄₁₆ × 32 ½ × 31 ¾ in.)
Collection of the Jesuit Fathers, Heverlee, on permanent loan to the Africa
Museum, Tervuren, 1322

The leopard represented in this mask is a metaphor for leadership and the authority of the traditional chief, who by rights claims the skin of any leopard or feline predator killed in the forest. Genets, civets, and leopards frequently appear in initiation masks, figures, and panels (cats. 11, 21, & 22) to remind the initiates to respect the authority of elders, title-holders, and ancestors.

The balloon-shaped headdress consists of sections of raffia cloth sewn together and stuffed with plant materials. One section bears traces of the original polychrome decoration that covered the entire headdress. Two projections at the bottom of the headdress may represent the animal's paws.

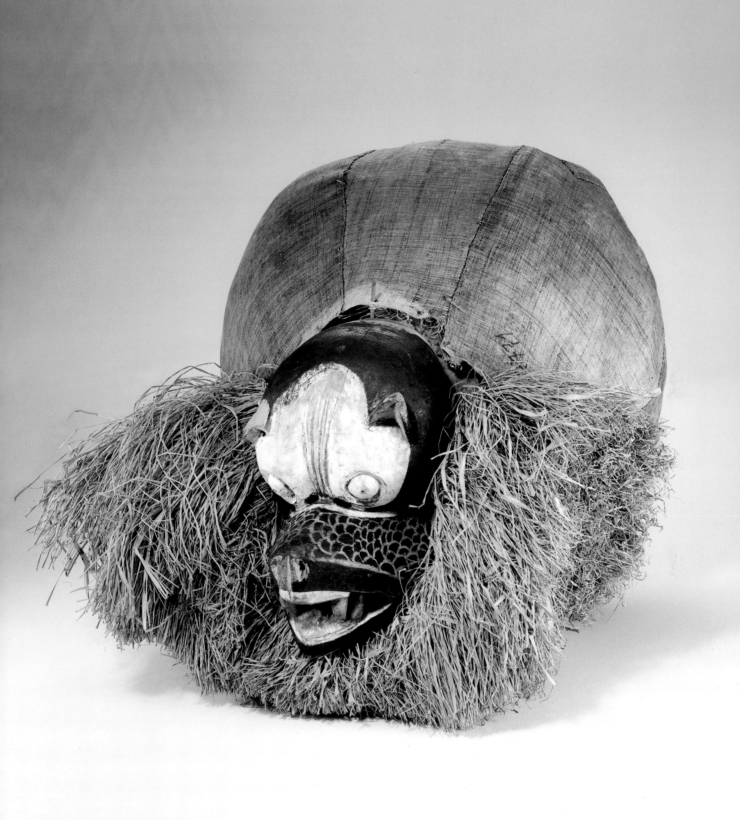

27 *Pig mask*

Nkanu peoples, Democratic Republic of the Congo
Wood, fiber, cloth, pigments
53 × 44.5 × 40 cm (20 ⅞ × 17 ½ × 15 ¾ in.)
Africa Museum, Tervuren, RG67.63.50 (aquired in 1967)

For the Nkanu, a pig symbolizes the impurity of
an uncircumcised man.[35] It is also associated with
promiscuity, an undesirable trait in a responsible
adult. The pronounced headdress is decorated with
triangles and cowrie shell designs, which are symbols
of good fortune and fertility because of their
resemblance to the female genitals.

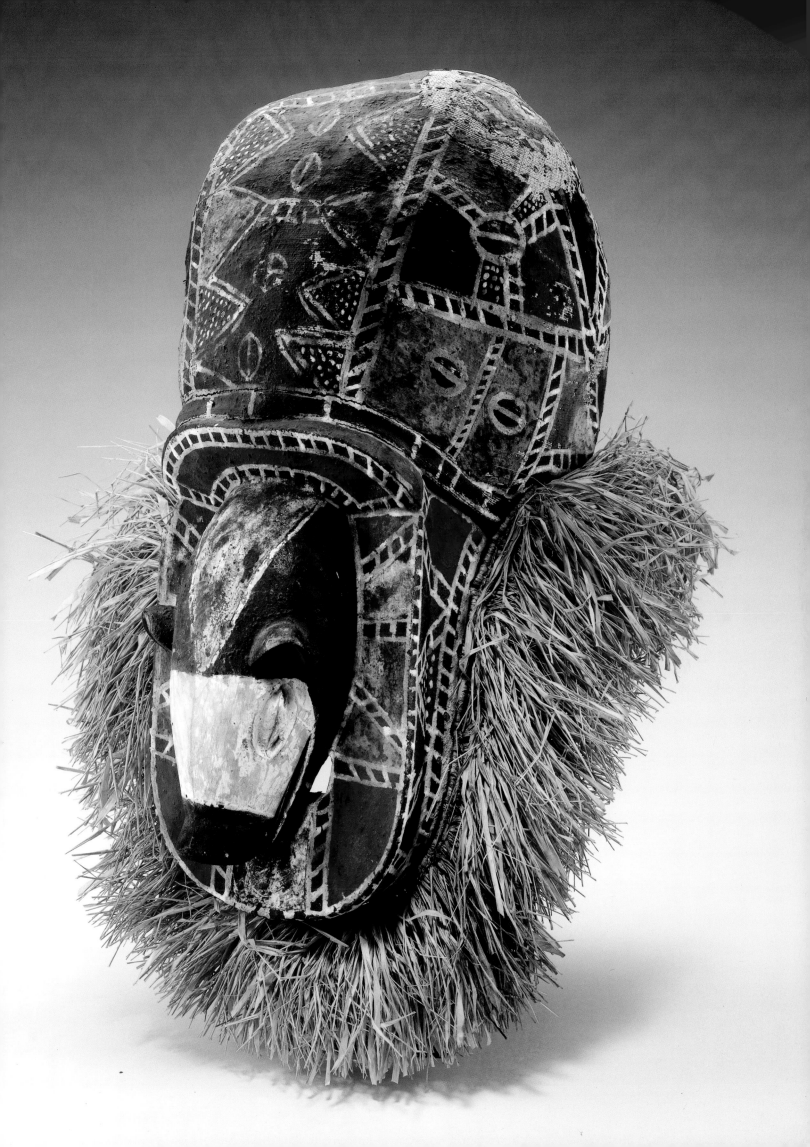

Head posts

Makala ma nkanda (sing. *(di)kala)* is the name given to carved posts made especially for *nkanda*. The posts are carved with the same facial characteristics as the four most important initiation masks: Kakungu, Nkoso, Kisokolo, and Makemba.[36] The posts, like the masks, protect the initiates' fertility and combat the malevolent intentions of others. In fact, the posts can actually "replace" the masks when the latter are unavailable. Individuals experiencing fertility problems associated with the *nkanda* rites may be treated by a healer at the *kakungu* post. Usually, the healer prefers to visit the patient at home and erect a smaller post during the healing ritual (fig. 47).

The *kala di kakungu,*[37] the largest of all posts, announces the *nkanda* is in process and warns off women, sorcerers, and the uninitiated (fig. 48). It is positioned on the main road leading from the *nkanda* enclosure to the village: Kakungu is positioned to "look" in the direction of the village.[38] A sharpened stick with the head of a cock "that has not sung yet"[39] pierces the ground next to the post. At its foot lies a stone with a palm nut or *mbidi* fruit

and an egg attached to it with a honey-based glue. The ritual specialist also places "projectiles" *(makuta)* at the base of the *kakungu* post.[40] The Nkanu believe that the egg and *makuta* will explode, striking sorcerers when they pass by. When the *kakungu* post is erected, the ritual specialist exclaims, *"Kakungu mpala-mpala, ga mpambu nzila, ntu wana!"* ("Kakungu [with] the high forehead, at the crossroads the head does battle!").

The post remains in place at the close of *nkanda* and is subject to natural decay. Sometimes it is consumed by fire when the *nkanda* enclosure is burned. The visible remains of the *kala di kakungu* continue to warn people from continuing along the path: to enter where an *nkanda* has taken place may bring misfortune, specifically immediate infertility, to the trespasser.

The *kala di luvumbu* resembles the Kisokolo mask with its upturned nose (and in rare cases, two horns). It is erected in the middle of the courtyard of the initiation area or under the awning of the house where the ritual specialists spend the night in bad weather.

Fig. 47 Head posts set up by Nsiabula Malungidi in the house of Mfutila of Kisanguna-Kowa II, 1991

Fig. 48 Drawing of a Kakungu head post with a sharpened stick topped with the head of a cock and a stone with a palm nut and egg

28 *Head post*

Nkanu peoples, Democratic Republic of the Congo
20th century
Wood, pigment
55.9 × 14.6 × 12.7 cm (22 × 5 ¾ × 5 in.)
Iris & B Gerald Cantor Center for Visual Arts at Stanford University,
anonymous gift, 1989.110
Not on exhibit

The face of a Kakungu mask is immediately
recognizable on this head post with its red face,
concave eye sockets, and bulging cheeks. The egg-
shaped head features large almond-shaped eyes and
a nose and mouth that are set in the triangular space
between the eyes and the bulging cheeks. The mouth
is a simple slit filled with kaolin. The post presumably
had a collar of *futi* fiber around its neck; only the
pieces of wood used to attach the collar to the
sculpture remain.

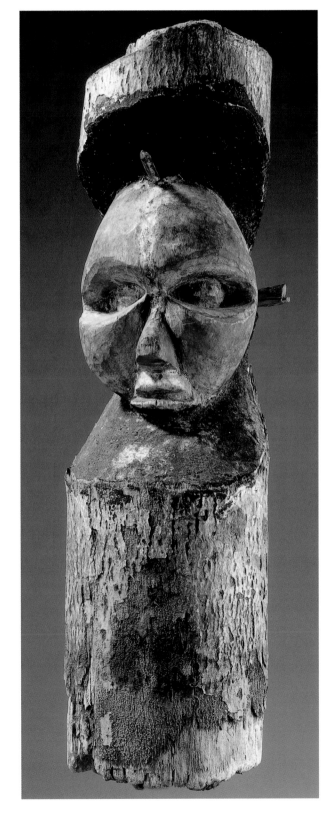

29 *Head posts*

Nkanu peoples, Democratic Republic of the Congo
Wood, fiber, pigments
41 cm (16 ½ in.) high, 45 cm (17 ¹¹⁄₁₆ in.) high
Collected by Sophie von Uhde in 1934
Institut für Ethnologie der Universität Göttingen, Abteilung
Völkerkundliche Sammlung, AF2238 & AF2239 (acquired in 1939)

These posts have the characteristic features of a
Kisokolo mask. The headdresses are decorated with
geometric patterns, and the skin that fits between the
"horns" of a Kisokolo mask is represented by a scaly
design. A thick raffia collar is attached below the
carved head on the post.

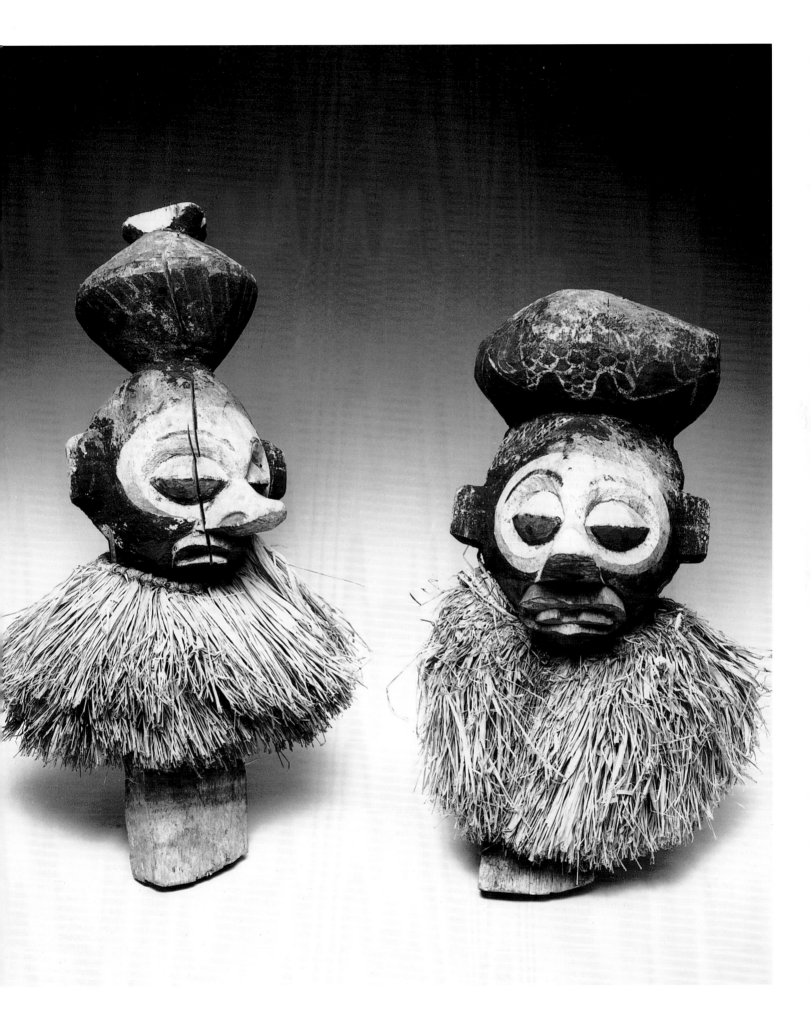

Notes

1 In his work on the Yaka, Plancquaert (1930: 59) points out that the initiation panels which have been classified as being made by the Yaka are in fact Nkanu pieces. The fact that the Yaka culture does not produce these kinds of objects—unanimously confirmed by my Nkanu sources—might suggest that the Nkanu are the only people who make polychrome panels. There are, however, other neighbors of the Nkanu who also build *kikaku* structures at the end of *nkanda.* These include the Mbeko, Lula, Ntandu, and Mbata or Zombo.

2 See wall panel (32.15.12) in the collection of the Musée de l'Homme, Paris.

3 Although the final phase with its festive departure and masked dances occasionally might not take place, the *kuyola Nkoso* phase must be carried out. This illustrates the importance of this stage of the initiation ritual and the *kikaku.*

4 Sacred is used here in the sense of encompassing the most fundamental ideas of a people's world view.

5 As Devisch writes about the *nkita (khita)* fertility ritual, he also points out that there are similarities between the *nkita (khita)* and *nkanda (n-khanda)* rituals.

6 To the Nkanu, what remains hidden is associated with sorcerers and malevolent forces.

7 Other informants describe the motif as a spider web or an "eye."

8 The beads included blueish-black glass beads (*bidingu,* also used as currency), white round beads or "fly eggs," pink round beads or "caterpillar heads," and red glass beads *(binsola).*

9 A flock of *nkumbi-nkumbi* birds circles a spot for some time before landing. This circular flying behavior is called *kudienga.* Nkanu children perform a ring dance called *madiedie, madila,* or *nkumbi-nkumbi* where they run in a circle, holding hands and swaying their arms and shoulders. At the end of the song they change direction and repeat *"A nkumbi, e . . ."* The song compares the circles made by black stork in flight to the presence of the Supreme Spirit (Nzambi).

10 During field research I assembled a list of artists who were active in the first half of the 20th century. Some of these artists must have carved objects illustrated in the catalogue *Spectacular Display.* Looking at the list of artists, most of whom lived in and around Kimvula, I am struck by the number of *nganga luvumbu* from the Kinsaku-Lau clan and the community of Kingemba-Kinga. Artists, their communities, and clans include: Buyamu of Kingemba Kinga (clan Kinsaku Lau); Dimonika of Kinzanzu (clan Kinzao); Fusu of Kingemba-Kinga (clan Kinsaku Lau); Lundimu of Kimakundi (clan Kingunda); Mfuka of Kipindi (clan Kinsaku Lau); Mpendani of Kikutikama (clan Kinkondongo); Ndombasi Mbota of Kintombo, a hamlet of Kingemba-Kinga (clan Kinsaku Lau); Nkolo of Kingemba-Kinga (clan Kinsaku Lau); chief Nsaku of Kinsaku-Lona (clan Kinsaku Lau); Nsebani of Kipindi (clan Kinkenga); Ntoko of Kinlongo (clan Kikialungu); Senda of Kinzanzu (clan Kinzao); and Paul Makengo of Kitongika (father of Mayimuna Magebuka).

11 Information about Nsebani was gathered through interviews with his son, Pascal Nkolo, in Kinshasa, and a number of other family-members.

12 An Nkanu saying declares *Nkela ugondele nzau, kusa masi* ("The gun that killed an elephant, rub it with oil"). That is, one should be thankful for what the gun has brought. Give the weapon its due.

13 The rooster is called nka Mbungu or Lord Mbungu. If the rooster dies during *nkanda,* the entire proceedings stop immediately. The carcass is thrown into the forest and the boys are sent home to await the closing ceremony *(kutuka).*

14 To the Yaka, the elephant is a totemic animal representing the procreative powers of the circumcised and the specialists during *nkanda.* The hooked nose of some of the Yaka masks and the post placed in front of the *nkanda* house are said to represent an elephant's trunk and are considered phallic symbols (Devisch 1972: 155).

15 A *kibika* decorated with beads is called *mpaka.* For examples of these costume elements, see Lema Gwete 1982: 74–77.

16 According to Emile Mbandu, the position of the child on the hip suggests the woman is a wet nurse or the child is three months old if it is a boy, four months if it is a girl. A mother never carries a younger baby on her hip, because doing so might injure her pelvis, vagina, and anus.

17 Joseph Maes interpreted the male figure's gesture in 1924 in *Aniota Kifwebe. De maskers uit Belgisch Congo enhet materiaal der besnijdenisritussen,* pp. 67–68, figs. 58–59.

18 This type of mask was reportedly made only in the eastern part of the Nkanu region.

19 This action, which the prospective initiates have to undergo repeatedly before and after circumcision, is comparable to those in the *ngunda* and *kusengula* ceremonies.

20 According to Nsiabula Malungidi, an Nkanu informant, there are no fixed rules for the composition of the feather crown. Only the feathers of large, noble birds are used; chicken feathers are not. The birds can be categorized in three groups: birds of prey (sparrow hawk, osprey), toorakoos or plantain-eaters, and hens (quails, guinea fowl) from, respectively, the forest, the savannah, and the village. Perhaps this allows Nkoso to cross the boundaries between these different environments?

21 Only the leader of the initiates, Mbala, is denied this right. "Nkoso is Mbala's son-in-law" was the reason I was given for this injunction.

22 The sword is the parade weapon of a Lunda or Luwa ruler, whereas the flywhisk is the symbol of the Nkanu chief's authority.

23 The fiber collar around the Kakungu mask face normally consists of *mafuti. Futi* is a liana species that grows near rivers, an environment that is considered the home of the ancestral spirits. Presumably, it is this connection between the plant and the ancestors that lends the material a certain power for the Nkanu.

24 There are also some examples of Kakungu masks with a white face.

25 An opposite interpretation of Kakungu's physiognomy (among the Yaka) can be found in Himmelheber (1939: 33). According to him, the bulging cheeks of the Yaka specimens are a sign of vitality. He adds that the new candidates are confronted with Kakungu on the day of their circumcision, to tell them that they should become just as big and strong as the Kakungu mask "with the powerful cheeks."

26 The relationship between the termites and the initiates is illustrated by the following Nkanu or Yaka riddle, recorded by Ryckmans (1957: 577, n 57): *"Matoko matuka ku mkhanda mlele nya-nya. Butswa"* ("The boys who leave the initiation enclosure are all dressed the same. Flying ants."). The author clarifies: "*Mkhanda,* initiation enclosure . . . for the rites of circumcision. The flying ants leave the termite hill by the thousands, at the close of the day."

27 The oral traditions of the peoples who live in the Lower Kongo and Kwango area mention short individuals with large heads and round bellies. When they fell, the weight of their heads prevented them from getting up again. They would call for help by blowing a whistle worn around the neck.

28 Some authors relegate stories about Mbaka-mbaka (who have been referred to by the derogatory term *pygmy*) on the banks of the Kwango to the realm of myth. The oral traditions of the Nkanu (as well as the Mbeko, Lula, Mpangu, Yaka, Suku, and others) indeed mention encounters of their ancestors with the Mbaka or Mbwiti—when the ancestors occupied their present territories. There are historical documents from the 16th, 17th, and 18th centuries pointing to an Mbaka presence north of the Kongo (by the Kwilu-Niari River), at the court of Kongo and Loango, in Loanda and east of the Inkisi (in what was then Mbata province). For an opposing interpretation see Lamal (1965: 88).

29 According to Domingiele Mvwaka, the name refers to the female sex, more specifically the clitoris. Nzondo is a mythical character with just one eye, one ear, one arm, one breast, and one leg; the counterpart of the completely bisexual being Mahungu. Both creatures are said to have lived at the beginning, before the appearance of human beings.

 According to some sources, facial tattoos distinguish the Kakungu and Nzondo forms. Kakungu has parallel colored stripes at his temples, while Nzondo has a single stripe on her nose. When the tattoo consists of dots, the male form has one stripe on his cheeks, while his female counterpart has three. Domingiele Mvwaka, on the other hand, mentioned a turtle shell that was given the name *nzondo* and was added to the Kakungu mask.

30 While conducting research, I met two Nkanu elders with *n'ganzi* scarification patterns on their faces, curved lines connecting the temples with the nostrils.

According to informants, the Yaka had no such facial decorations. Nevertheless, several Yaka sculptures (both masks and statues) display this design.

31 All spotted felines are associated with the authority of the traditional chief.

32 Dr. Plischke of the Institut für Ethnologie der Universität Göttingen, Abteilung Völkerkundliche Sammlung asserts there is a relationship between the Kisokolo mask and the elephant, which is clear from the ethnographic data collected by S. von Uhde in 1939 and the mask (cat. 24). In letters von Uhde described the use of the horned mask in following the trail of an old elephant bull and wrote that the Nkanu dance with the mask at full moon "in order to spot an old elephant bull, a loner."

33 Ntandu sources told Van Wing that the neophytes were forced to cry as the enclosure where they had spent so much time was set on fire. "They dance, shaking their heads in sadness, or contort themselves in violent convulsions, shedding hot tears. Because the guardians tell them, 'if you do not weep for the death of the *longo [nkanda],* you will never have children'" (Van Wing 1921: 371). In another interpretation, the lines on the cheeks of both the Makemba and Kisokolo masks are not interpreted as tears but as vertical tattoo marks, indicating their authority as sanctioned by the ancestors.

34 The *ndona* is a woman who is chosen from the traditional chief's clan and spends some time with him in the *kimpasi ki nkita* to be enthroned afterwards. Like the chief, the *ndona* may safeguard clan emblems.

35 The animal is associated with anything that is dirty or filthy. In villages where pigs are raised, people are bothered by sand fleas. Pig's meat, unlike goat's meat, is not eaten on special occasions. It is also improper to use pigs as sacrificial animals.

36 I will only discuss the *makala* types that are illustrated in the exhibition catalogue. Other types include the *kala di ndilu,* which derives from the Nkoso mask, and the Makemba post.

37 I was able to determine that *kala di Kakungu* is used as a general term for all cephalic sculptures that function in the context of the *nkanda.*

38 It may seem contradictory that Kakungu—who was identified as a blind elder—was positioned as a guard.

39 That is, a very young animal.

40 Nsiabula Malungidi described how he sets up the Kakungu post. He paints the sculpture made from n'gela wood with white, black, and red pigments. In the hole he has dug, he puts the *makuta,* made from a little hunting powder, crushed iron slag, small sharp rocks, glass shards, and some powder consisting of scraped bark from the *mbota* and *mfilu,* pulped leaves from the *mvuma* and *mpeti.* After putting in the *makuta,* he plants the Kakungu post in the hole. Then the *nganga* spits a chewed cola nut onto the head of the post.

Bibliography

Bastin, Marie-Louise. 1961. *Art décoratif Tshokwe*. 2 vols. Lisbon: Museu do Dundo.

_____. 1994. *Sculpture Angolaise: Mémorial de cultures*. Lisbon: Museu Nacional de Etnologia.

Bentley, W. Holman. 1887. *Dictionary and Grammar of the Kongo Language As Spoken at San Salvador, the Ancient Capital of the Old Kongo Empire, West Africa*. London: Baptist Missionary Society & Trübner & Co.

Biebuyck, Daniel P. 1985. *The Arts of Zaïre*. Vol. I, *Southwestern Zaïre*. Berkeley: University of California Press.

Boone, Olga. 1973. *Carte ethnique du Congo Belge de la République du Zaïre: Quart Sud-Ouest*. Tervuren: Musée Royale de l'Afrique Centrale.

Bourgeois, Arthur P. 1984. *Art of the Yaka and the Suku*. Meudon, France: Alain & Françoise Chaffin.

_____. 1985. *The Yaka and Suku*. Iconography of Religions, 7, D1. Leiden: E.J. Brill.

Butaye, R. 1910. *Dictionnaire Kikongo-Français, Français-Kikongo*. Roulers: De Meester.

Coart E. and A. de Hauleville. 1906. *Notes analytiques sur les collections ethnographiques du Musée du Congo*. Vol. I., *Les arts, la réligion*. Tervuren: Musée du Congo belge, pp. 145–315, pl. 22–62.

Cornet, Joseph. 1972. *Arts de l'Afrique noire au pays du fleuve Zaïre*. Brussels: Arcade.

_____. 1975. *Art from Zaïre: 100 Masterworks from the National Collection*. New York: African-American Institute.

Cuvelier, Jean. 1946. *L'ancien royaume de Congo*. Bruges and Paris: Desclée de Brouwer.

Dapper, Olfert. 1676. *Nauwkeurige beschrijvinghe der Afrikaensche gewesten van Egypten, Barbaryen, Libyen, Biledulgerid, Negroslant, Guinea, Ethiopiën, Abyssinie. . .* 2nd ed. Amsterdam: Jacob van Meurs.

Davister, J. 1937. "Kimvula: histoire et génèse du poste." In *Diaire de Kimvula (1896–1924)*.

de Heusch, Luc. 1982. *Rois nés d'un coeur de vache*. Mythes et rites Bantous, II. Les essais, CCXVIII. Paris: Gallimard.

_____. 1988. "La vipère et la cigogne: notes sur le symbolisme tshokwe." In *Art et mythologie: figures tshokwe* by C. Falgayrettes. Paris: Fondation Dapper.

Dereau, L. and K.E. Laman. 1957. *Lexique: Kikongo-Français, Français-Kikongo*. Namur: Westmael-Charlier.

Devisch, Renaat. 1972. "Signification socio-culturelle des masques chez les Yaka." *Boletim do Instituto de Investigação científica de Angola* 9(2): 151–76.

_____. 1984. *Se recréer femme: manipulation sémantique d'une situation d'infécondité chez les Yaka du Zaïre*. Berlin: Reimer (Collectanea Instituti Anthropos), 31.

_____. 1993. *Weaving the Threads of Life: The Khita Gyn-Eco-Logical Healing Cult Among the Yaka*. Chicago and London: The University of Chicago Press.

Felgas, Hélio. 1965. *As populaçãos nativas do Norte de Angola*. 2nd ed. Lisbon.

Felix, Marc Leo. 1987. *100 Peoples of Zaïre and Their Sculpture: The Handbook*. Brussels: Zaire Basin Art History Research Foundation.

Fu-Kiau, Kimbwandènde Kia Bunseki. 1969. *Le Mukongo et le monde qui l'entourait: Cosmogonie Kôngo*. Kinshasa: Office national de la recherche et de développement.

Gillon, Werner. 1984. *A Short History of African Art*. New York: Facts on File.

Hilton, Anne. 1985. *The Kingdom of Kongo*. Oxford: Clarendon Press.

Himmelheber, Hans. 1939. "Les masques Bayaka et leurs sculpteurs." *Brousse* 1: 19-39.

Huveneers. 1944. "Nkhanda, la région du Kwango et les autres. Popokabaka, le 01.12.44. *Dossier Jezuïeten, Heverlee* 14/5 n∞ 28.

Jacobson-Widding, Anita. 1979. *Red—Black-White as a Mode of Thought of the Peoples of the Lower Congo*. Uppsala: Almqvist & Wiksell International.

Labat, Jean Baptiste. 1732. *Relation historique de l'Ethiopie occidentale*. Paris. French trans., *Istorica descrizzione degli tre regni Congo, Matamba e Angola* by Giovanni Antoni Cavazzi, Bologna, 1687.

Lamal, F. 1965. *Basuku et Bayaka des districts Kwango et Kwilu au Congo*. Annales Sciences Humaines, 56. Tervuren: Musée Royal de l'Afrique Centrale.

Lehuard, Raoul. 1993. *Art Bakongo, les masques*. Arnouville-les-Gonesse: Arts d'Afrique Noire.

Lema Gwete, Alphonse. 1975. *Sura Dji, Visages et racines du Zaïre*. Paris: Musée des arts décoratifs.

_____. 1993. "An Introduction to Nkanu and Mbeeko Masks." In *Face of the Spirits: Masks from the Zaire Basin*, ed. by Frank Herreman & Constantijn Petridis. Antwerp: Etnografisch Museum.

Lima, Augusto Guilherme Mesquitela. 1970. *Carta Etnica de Angola*. Luanda.

MacGaffey, Wyatt, and Michael D. Harris. 1993. *Astonishment and Power*. Washington, D.C.: National Museum of African Art and the Smithsonian Institution Press.

Maes, Joseph. 1924. *Aniota Kifwebe: De maskers uit Belgisch Congo en het materiaal der besnijdenisritussen*. Antwerp: De Sikkel.

Maesen, Albert. 1969. *Umbangu: Kunst uit Kongo in het Koninklijk Museum voor Midden-Afrika*. 2nd ed. Brussels: Cultura (Kunst in België)

Mertens, Joseph. 1942. *Les chefs couronnés chez les Ba Kongo orientaux. Etude de régime successoral*. Brussels: Institut royal colonial belge.

Mudiji Malamba, Gilombe. 1989. *Le language des masques Africains. Etude des formes et fonctions symboliques des Mbuya des Phende*. Kinshasa: Facultés Catholiques de Kinshasa.

Nkunga Panzu. 1981. "L'image de l'homme à travers le rite d'initiation (circoncision). Licentieverhandeling." Undergraduate thesis, Institut Pédagogique National, Section des Sciences Humaines, Kinshasa.

Pélissier, René. 1986. *Historia das campanhas de Angola. Resistencia e revoltas (1845–1941)*. Vol. I. Lisbon.

Plancquaert, Michel. 1930. *Les sociétés secrètes chez les Bayaka*. Louvain: J. Kuyl-Otto.

—————. 1932. *Les Jaga et les Bayaka du Kwango: contribution historico-ethnographique*. Brussels: Institut royal colonial belge.

—————. 1971. *Les Yakas: Essai d'histoire*. Tervuren: Musée Royal de l'Afrique Centrale.

Ryckmans, A. 1957. "Choix de devinettes des BaNkanu et BaYaka du Territoire de Popokabaka." *Zaïre* 9(6): 563–92.

Struyf, Ivo. 1910–11. "De godsdienst bij de Bakongo." *Onze Kongo* 1(5): 464–78.

Thompson, Robert Farris, and Joseph Cornet. 1981. *The Four Moments of the Sun: Kongo Art in Two Worlds*. Washington, D.C.: National Gallery of Art.

Van Damme, Annemieke. 1998. "Beelden, maskers en initiatiepanelen bij de Nkanu en hun buren, de Mbeko en Lula. Socio-culturele context en stilistische analyse (Zone Kimvula, Congo)." Doctoral diss., Universiteit Gent, Letteren en Wijsbegeerte, Sectie Kunstwetenschappen.

Van Roy, Hubert. 1973. "Les Bambwiiti, peuplade préhistorique du Kwango." *Anthropos* 68: 815–80.

Vansina, Jan. 1965. *Les anciens royaumes de la savane, les états des savanes méridionales de l'Afrique centrale des origines à l'occupation coloniale*. Léopoldville: IRES.

—————. 1992. "History of Central African Civilization." In *Kings of Africa Art and Authority in Central Africa, Collection Museum für Völkerkunde Berlin*, ed. by Erna Beumers & Hans-Joachim Koloss. Maastricht: Foundation Kings of Africa.

—————. 1993. "Zairian Masking in Historical Perspective." In *Face of the Spirits: Masks from the Zaire Basin*, ed. by Frank Herreman & Constantijn Petridis. Antwerp: Etnografisch Museum.

Van Wing, Joseph. 1921. "Nzo Longo ou les rites de la puberté chez les BaKongo." *Congo* 1: 48–59, 365–89.

—————. 1938. *Etudes Bakongo*. Vol. 2, *Religion et magie*. Brussels: Institut royal colonial belge.

—————. 1959. *Etudes Bakongo: Sociologie, religion et magie*. 2nd ed. Museum Lessianum, Section Missiologique, 39. Brussels: Desclée de Brouwer.

Wassing, René S. 1977. *Die Kunst des Schwarzen Afrika*. Fribourg: Office du Livre S.A.

Weyns, J.A. 1946. "De plastiek van het Neder-Kongo-stijlgebied." Doctoral diss., Gent: Universiteit Gent, Letteren en Wijsbegeerte.

White, C.M.N. 1953, "Notes on the Circumcision Rites of the Balovale Tribes." *African Studies* 12(2): 41–56.